Tropical World

Millie Marotta

An Imprint of Sterling Publishing 1166 Avenue of the Americas New York, NY 10036

LARK CRAFTS and the distinctive Lark logo are registered trademarks of Sterling Publishing Co., Inc.

First published in the United Kingdom in 2015 by Batsford, an imprint of Pavilion Books Group, Ltd, as Millie Marotta's Tropical Wonderland: A Colouring Book Adventure

© 2015 by Millie Marotta

All rights reserved. No part of this publication may be reproduced, stored in a retrieval system, or transmitted in any form or by any means (including electronic, mechanical, photocopying, recording, or otherwise) without prior written permission from the publisher.

ISBN 978-1-4547-0913-8

Distributed in Canada by Sterling Publishing ^c/o Canadian Manda Group, 664 Annette Street Toronto, Ontario, Canada M6S 2C8

For information about custom editions, special sales, and premium and corporate purchases, please contact Sterling Special Sales at 800-805-5489 or specialsales@sterlingpublishing.com.

Manufactured in China

2 4 6 8 10 9 7 5 3 1

larkcrafts.com

Tropical World

a coloring book adventure

Millie Marotta

Introduction

Those of you who already own my first coloring book Animal Kingdom will know that my favorite things in life are drawing and the natural world—a match made in heaven in my opinion. Like Animal Kingdom, this book forms a collection of illustrations of flora and fauna, this time inspired by my own travels to far-flung places and all the exotic species that I have been lucky enough to see along the way. It also includes some of those that I've not yet been fortunate enough to see for myself in the wild, and so in that sense it also serves to satisfy my own flight of fancy and general obsession with nature. My illustrations always begin as fairly realistic drawings, keeping the overall form of the animal or plant quite true to life. I will then begin to elaborate and decorate, adding lots of pattern and detail to create something which is part real and part imagination.

Putting together the first book was both a new and exciting experience for me. As a commercial illustrator I was of course used to having my work out there in the public eye, but had never offered it to people in a way that they were being invited to contribute to the artwork themselves. I did feel a little nervous about how the book might be received—would people enjoy coloring my illustrations? Would they be charmed, as I was hoping, by my own interpretation of the animal kingdom? As it turns out the response to the book has been overwhelmingly positive and it has been a joy to share my work in this way with so many people.

I have discovered too that many readers felt they were getting a lot more from the book than just a creative activity, many have been in touch explaining how the book has helped them in some way through difficult times and has served as a form of "art therapy" for them. As someone who has always enjoyed drawing, painting, and doodling, I have always appreciated how therapeutic these types of creative activities can be and have been lucky enough that they have been a regular and important part of my life for as far back as I can remember. So to know that *Animal Kingdom* has been so much more than just a coloring book to many readers is wonderful.

It has been utterly fascinating to see how inventive readers are with their coloring and how they can transform a black and white illustration created by me into something completely unique and very much their own. With *Tropical World* I simply wanted to do the same thing again—to delight people with beautiful illustrations and inspire them to want to explore their creative side. And to offer a little bit of escapism.

Although *Tropical World* is predominantly a coloring book you will find a few pages dotted throughout with empty spaces, inviting you to embellish them with your own patterns, textures, and drawings. There is also a scattering of words along the way with suggestions of how or what you might add to the illustrations yourself.

A question I have been asked a lot since the release of Animal Kingdom is which I prefer myself for coloring—pens or pencils. I have to say that for me it will always be colored pencils, simply because I enjoy how versatile they are in allowing for shading and color blending, but that is just my personal preference. I think the most interesting thing for me is seeing how differently readers will approach the same image in terms of the colors and materials they choose, resulting in strikingly individual outcomes. While one person may go for a very calming harmonious palette in soft pencils, the next might choose a selection of lively vibrant colors that clash with one another, but each will achieve a great result. I guess what I'm saying here is that there are no rules, you will all begin with the same illustrations but your choice of colors is just that your choice. It is this that will make the images in your book uniquely yours, there is no right or wrong way to color, just go with what you feel and create a tropical world all of your own.

Millie Marsta

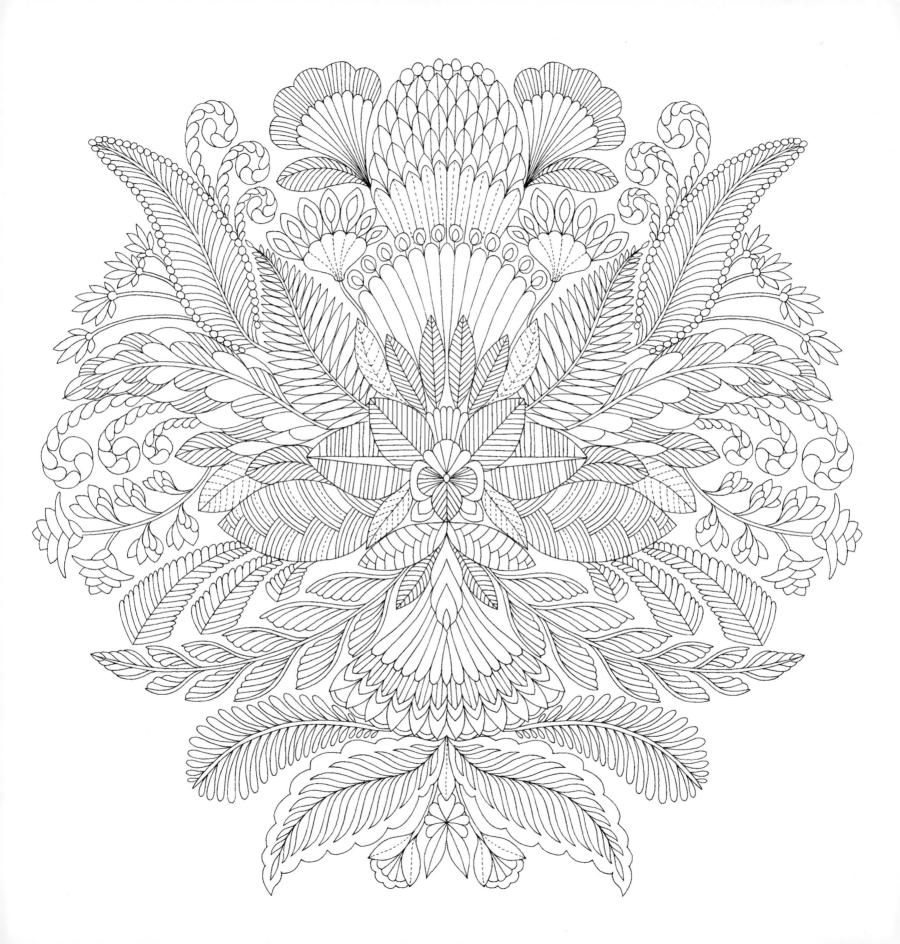

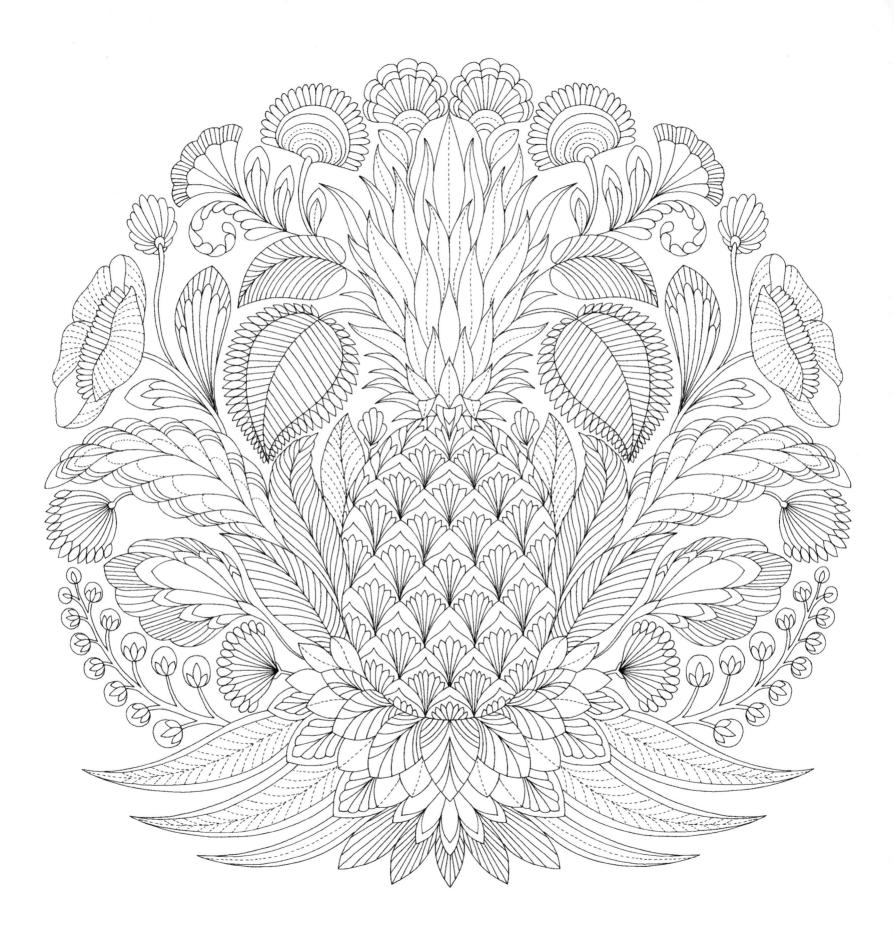

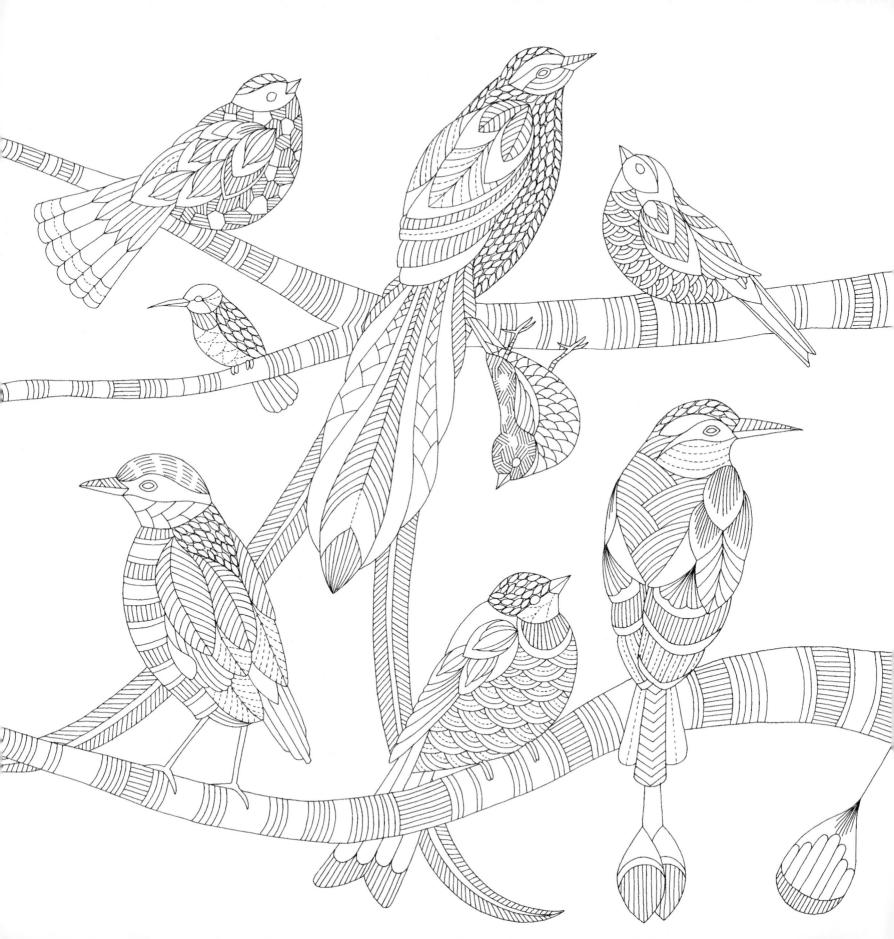

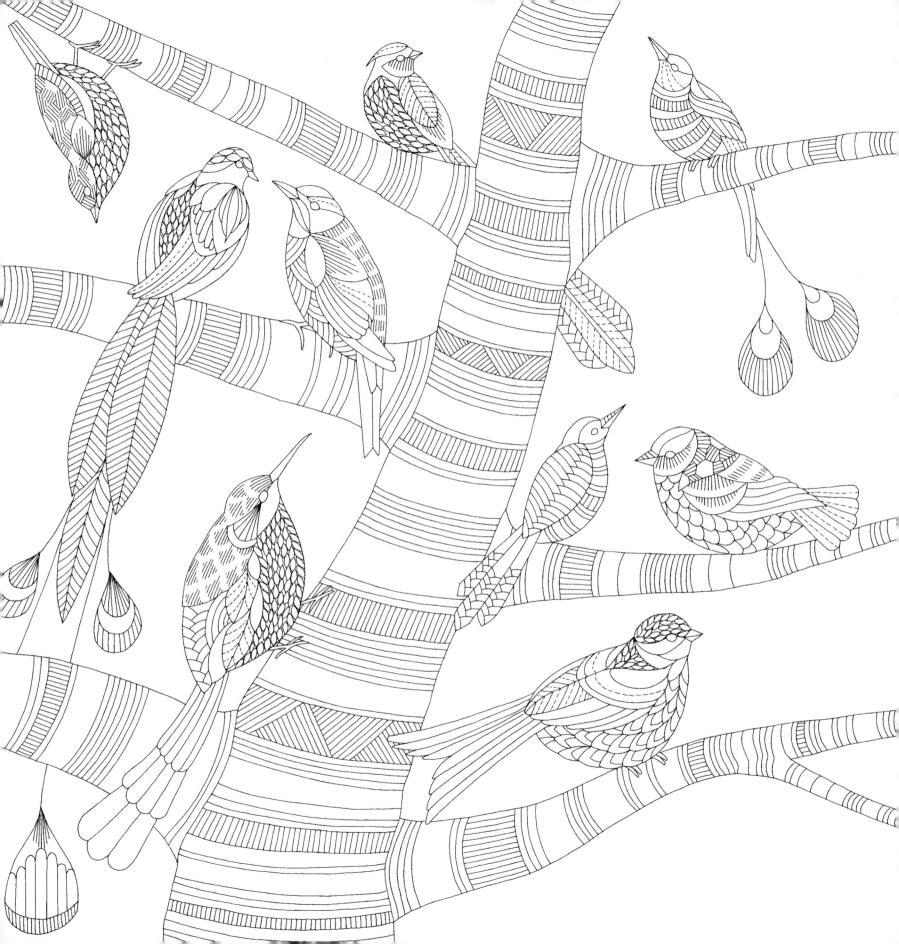

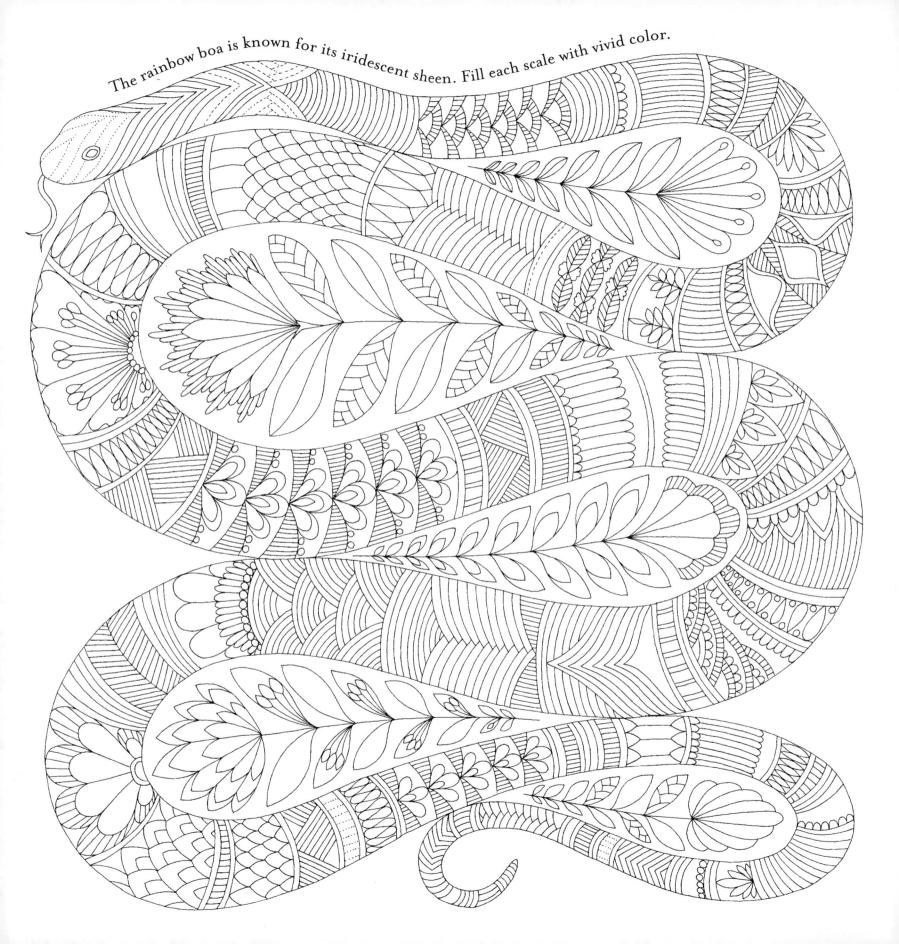

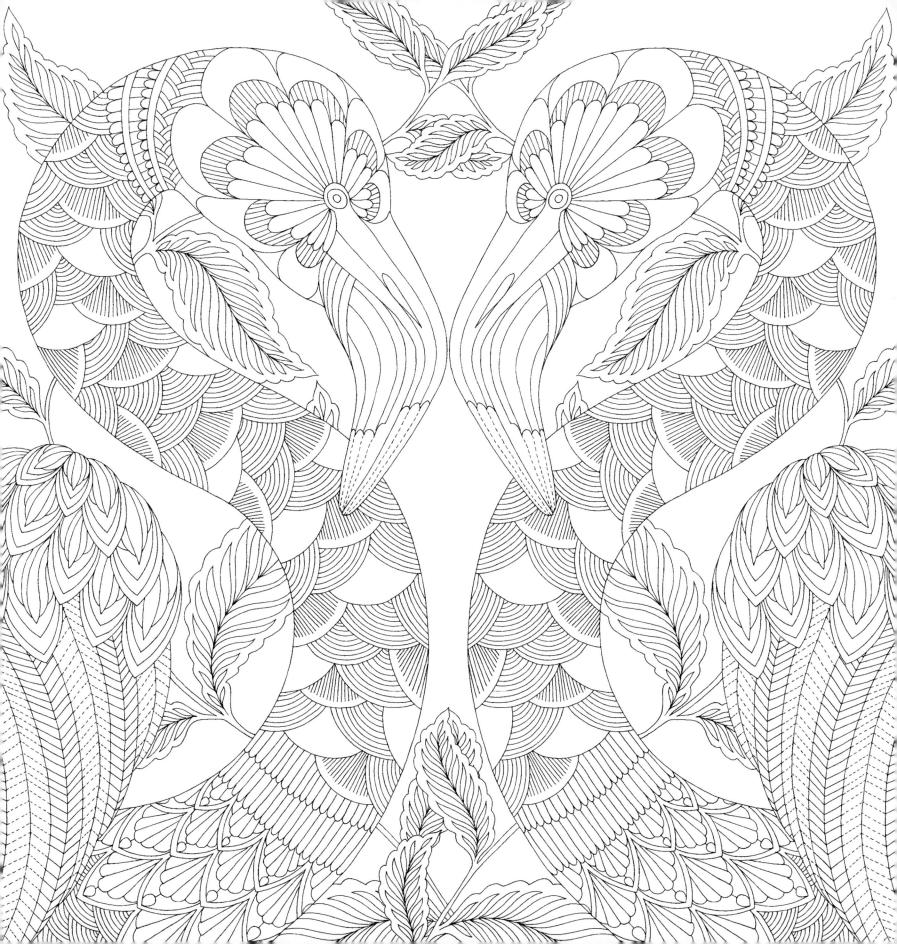

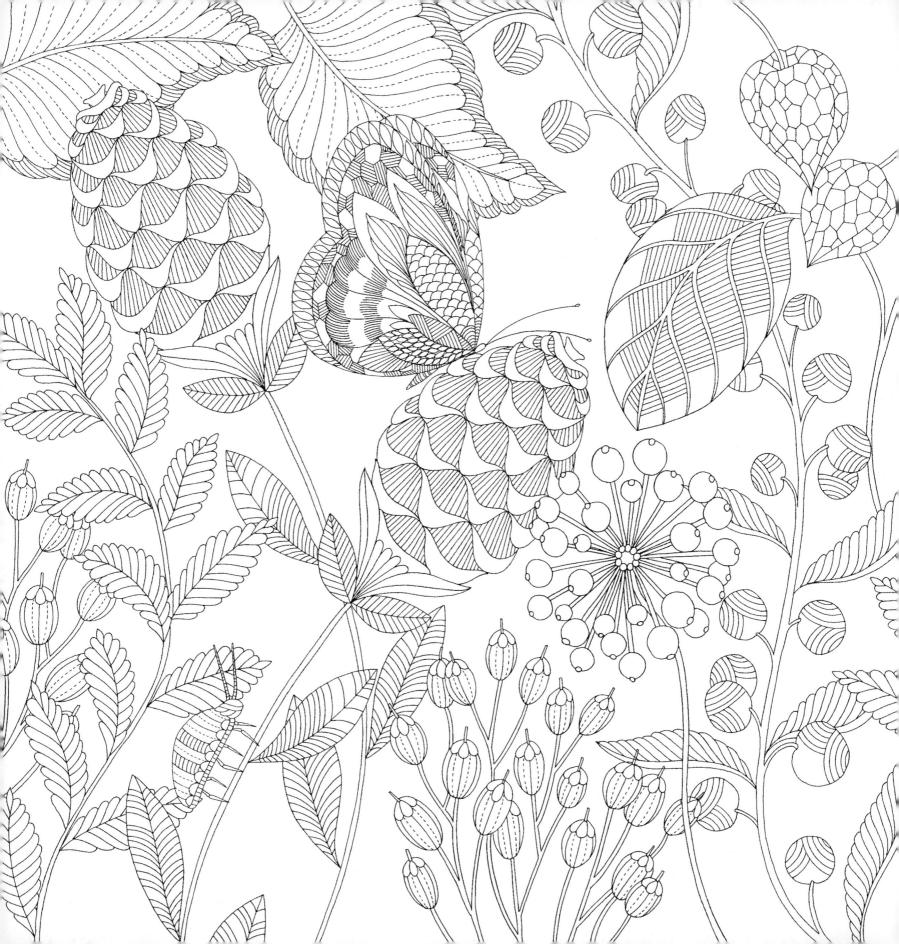

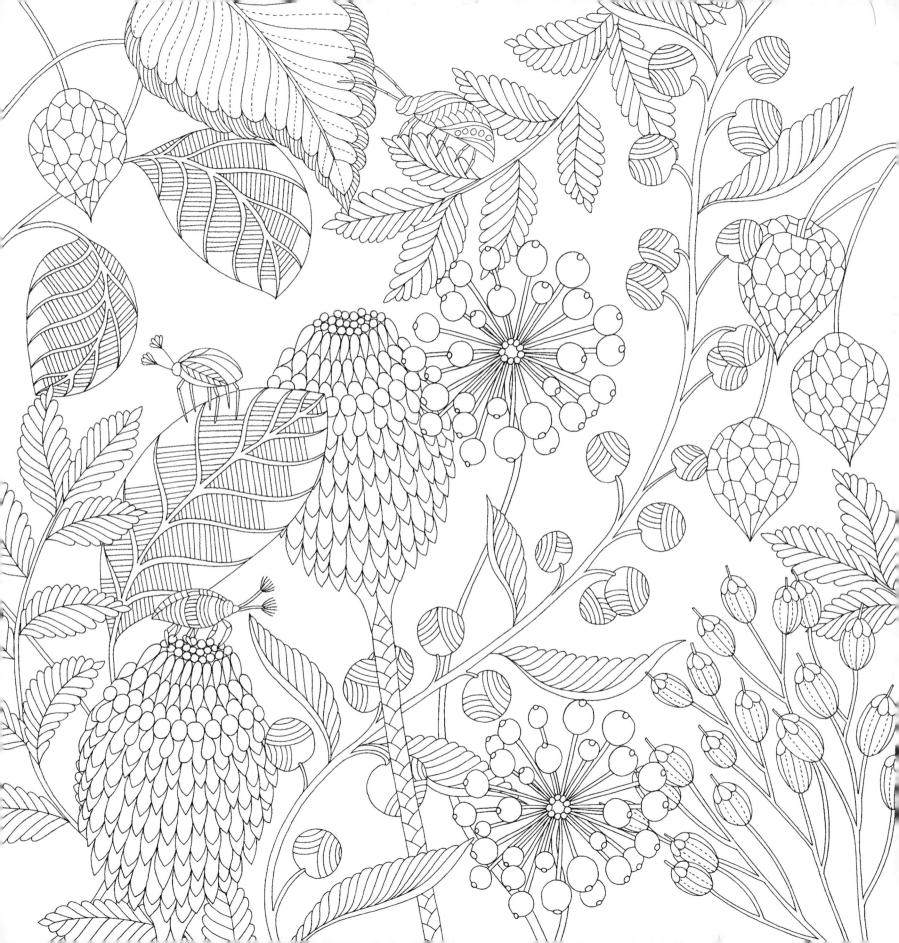

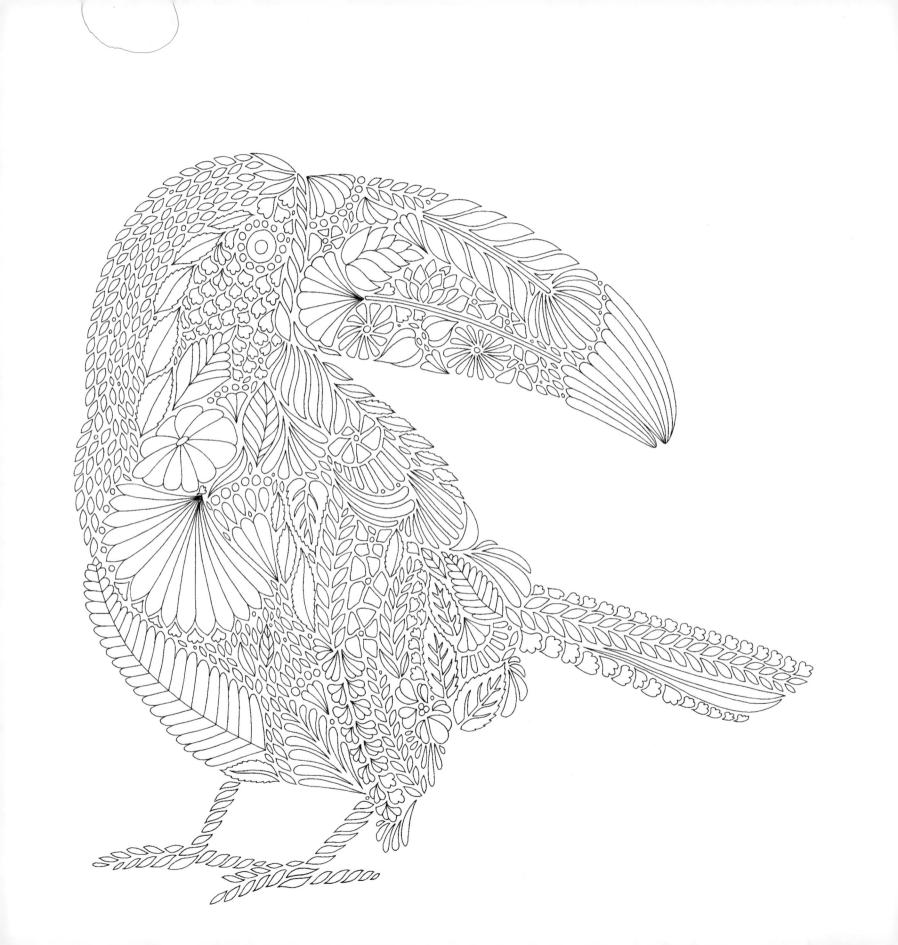

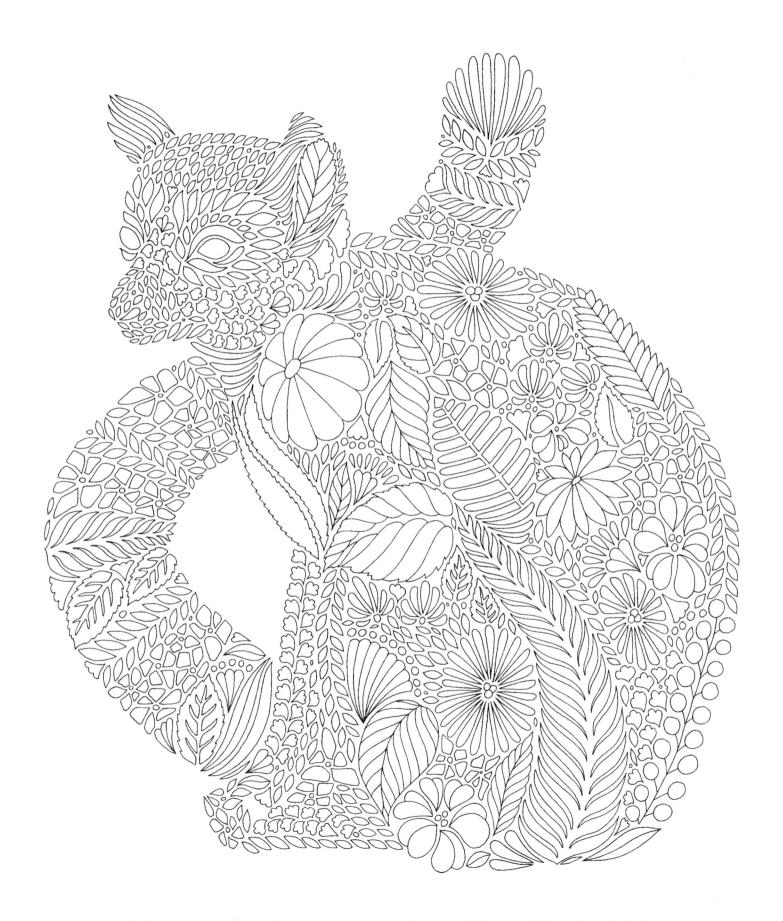

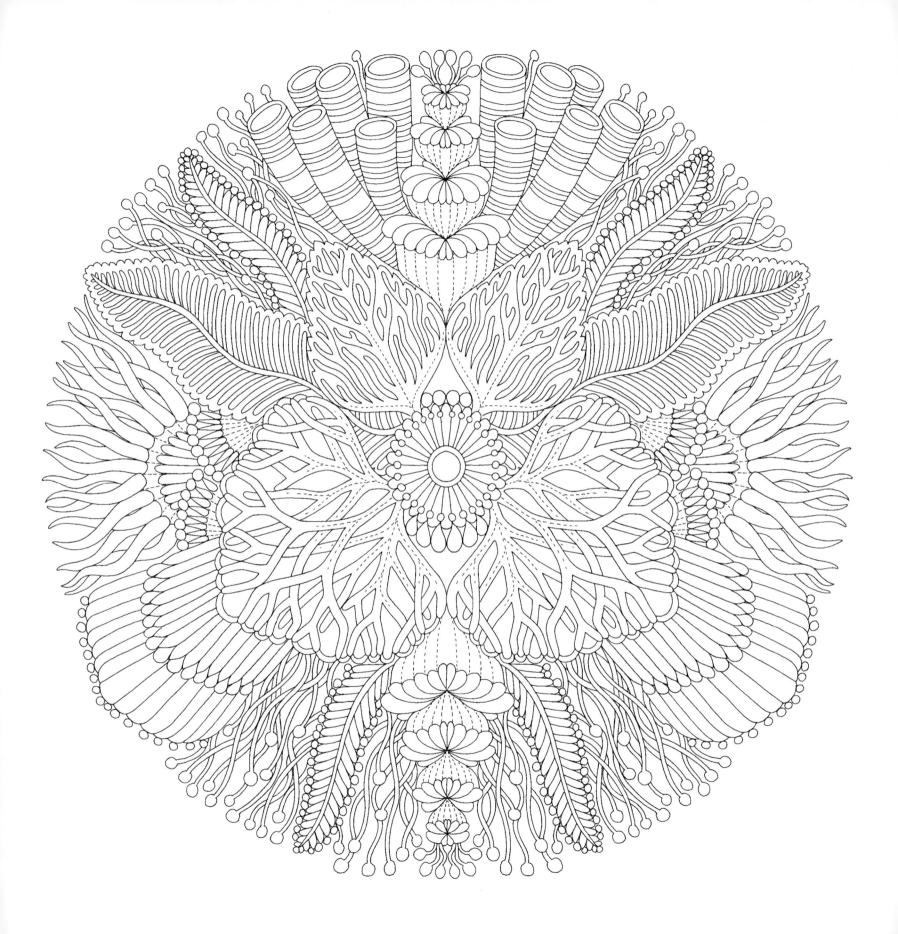

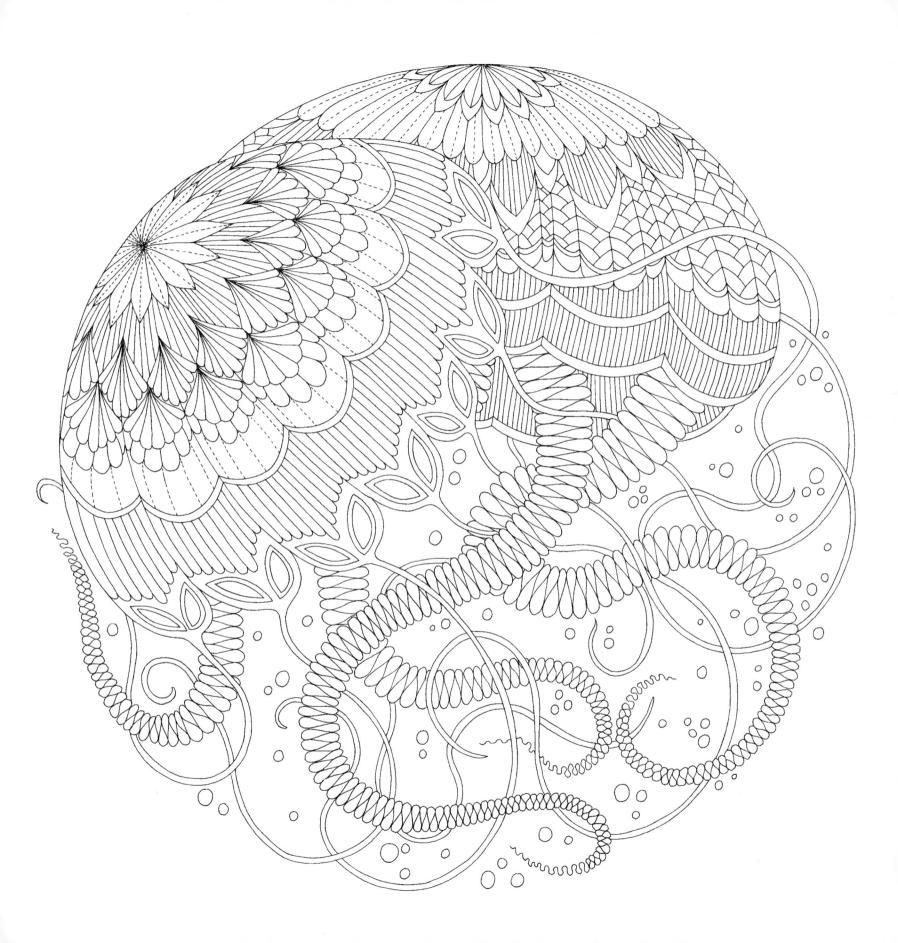

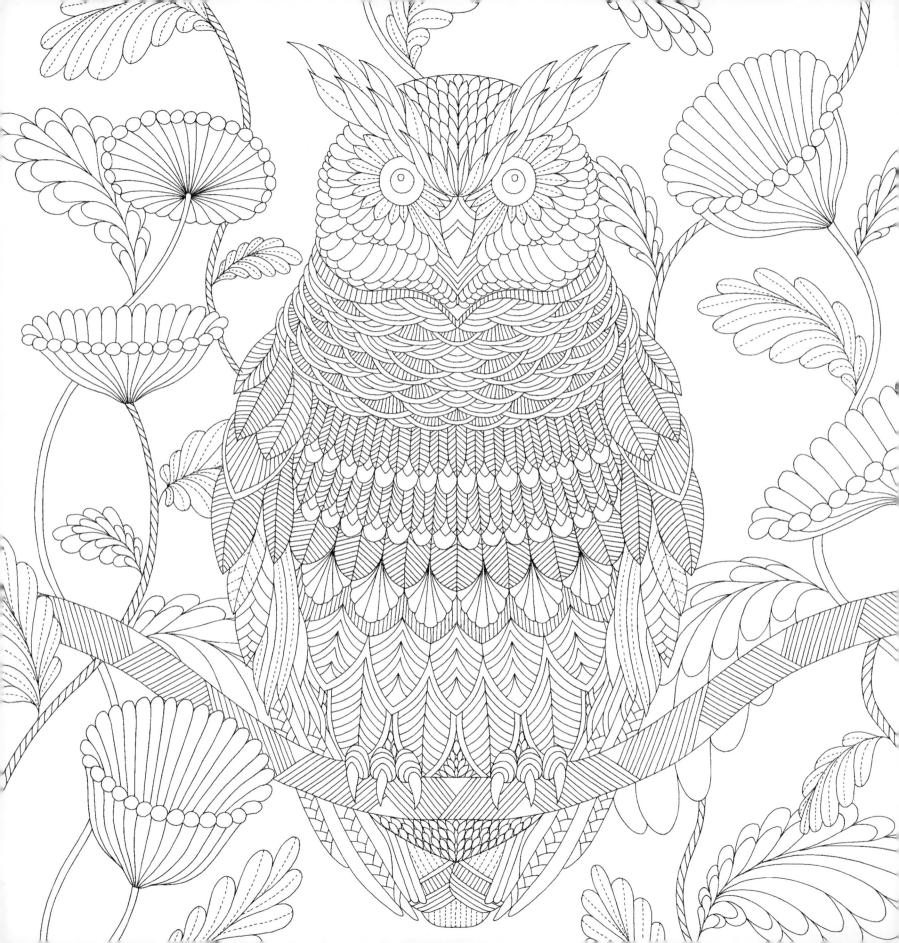

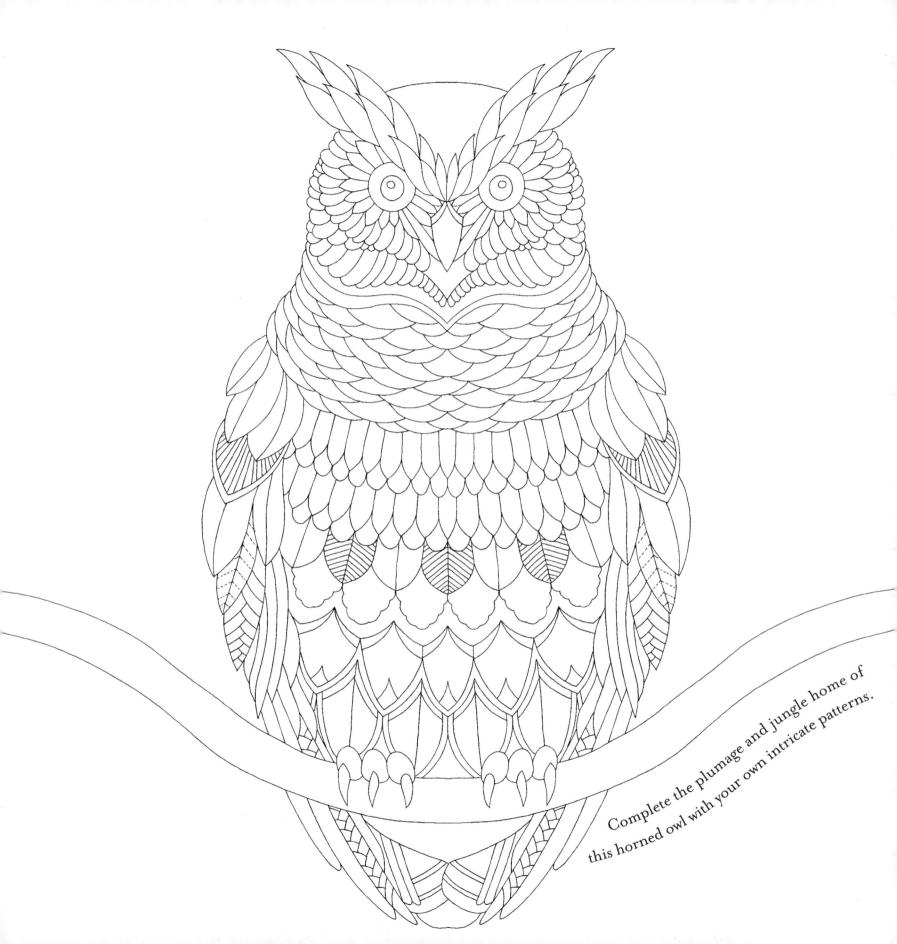

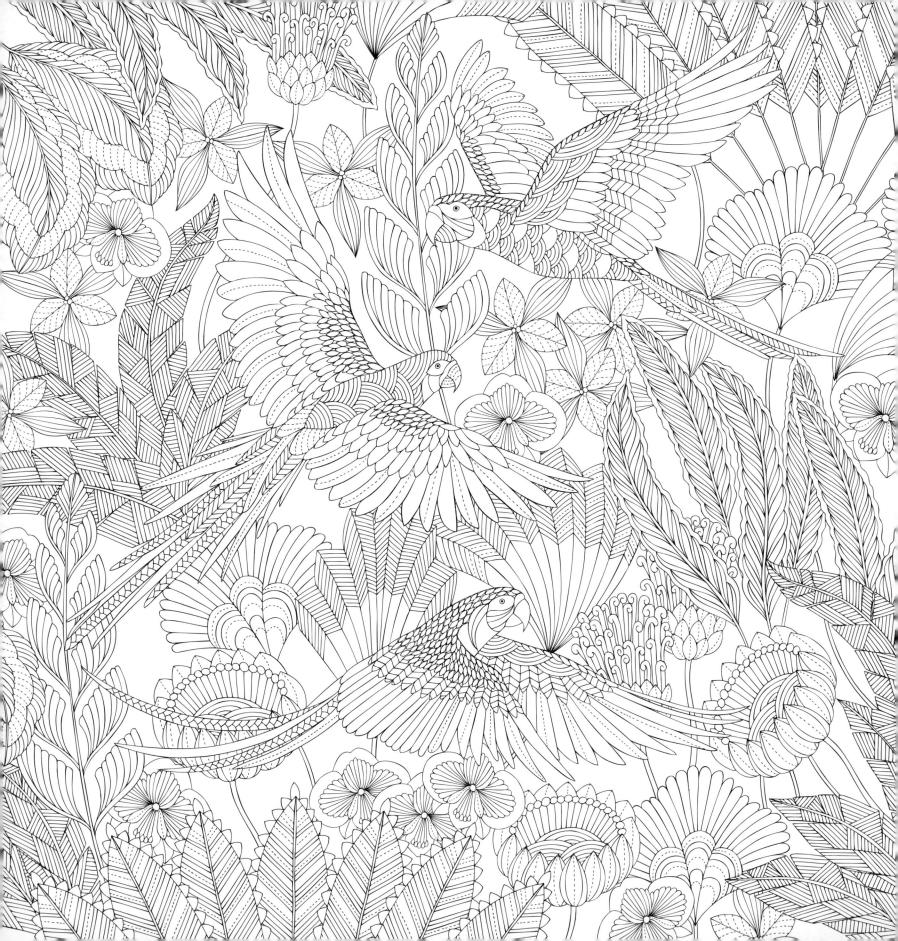

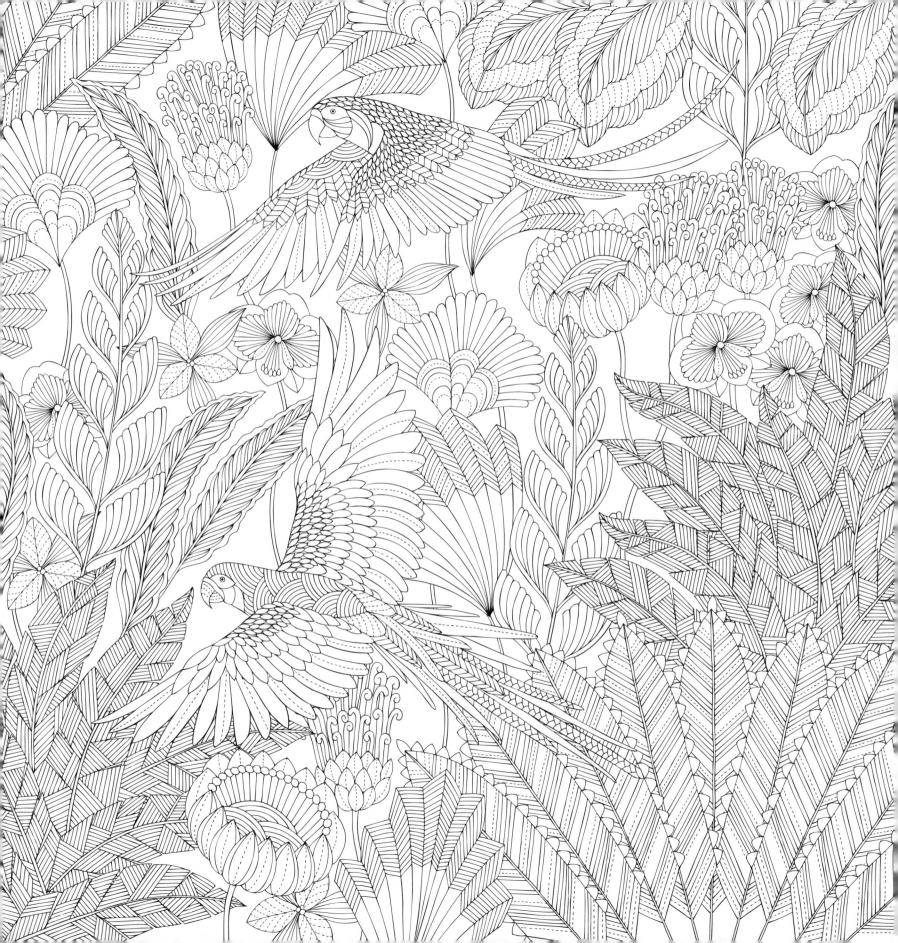

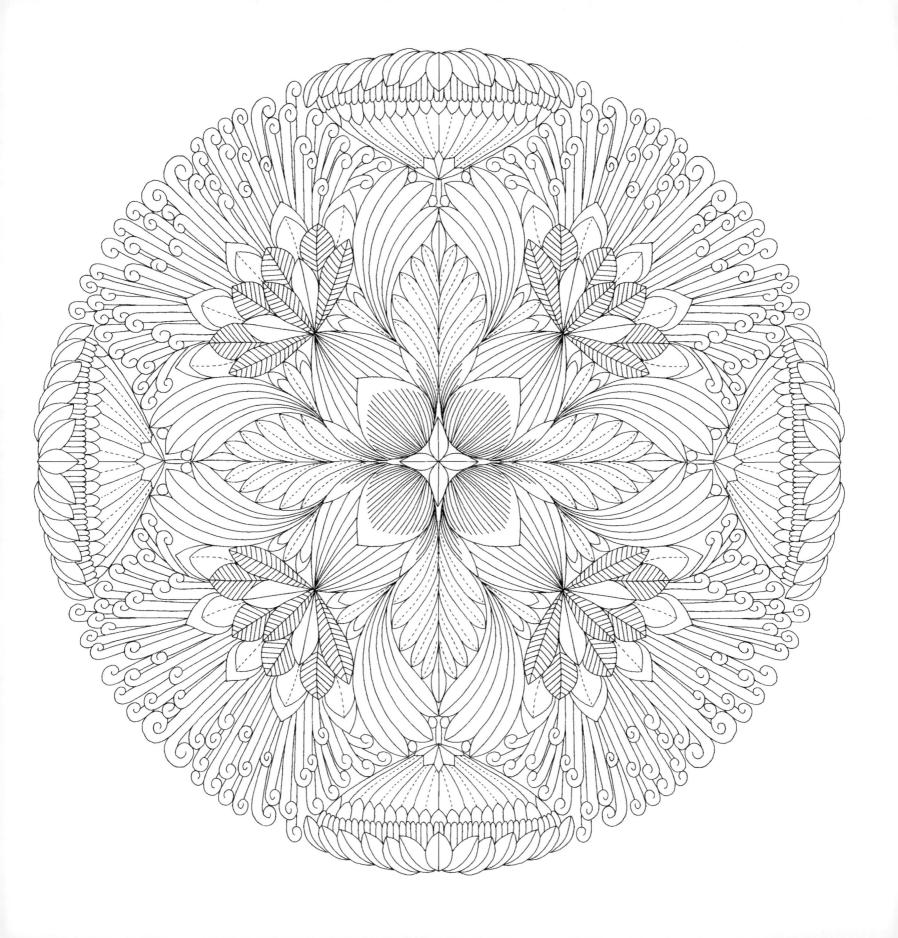

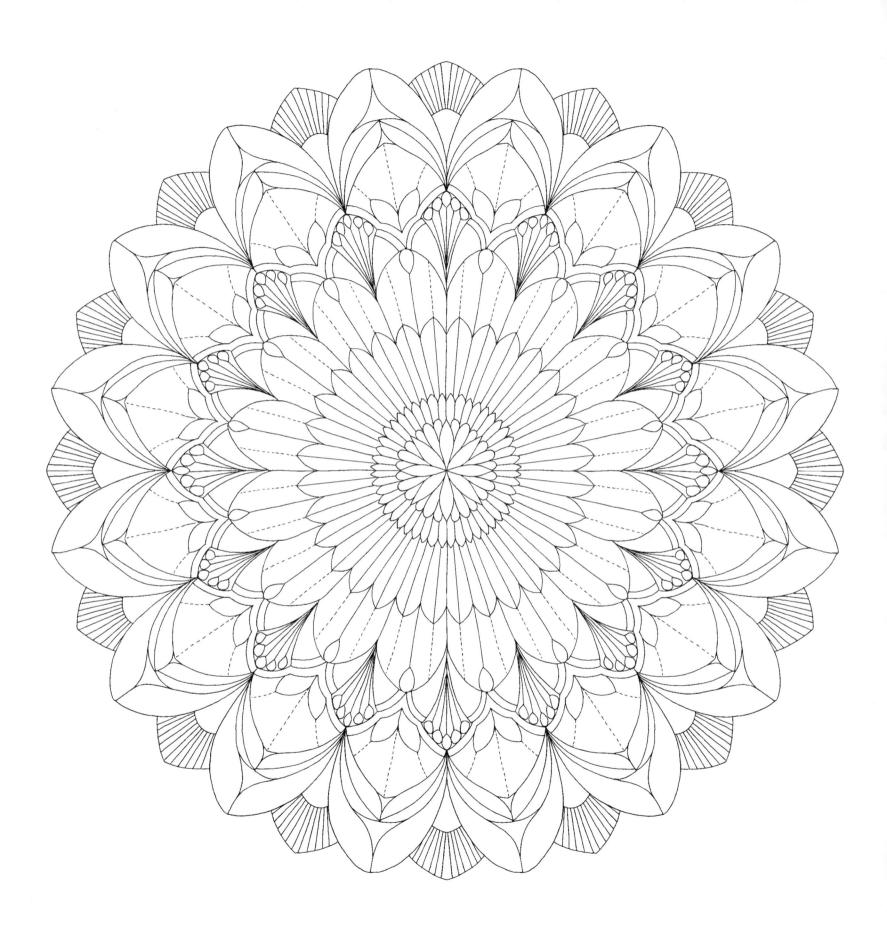

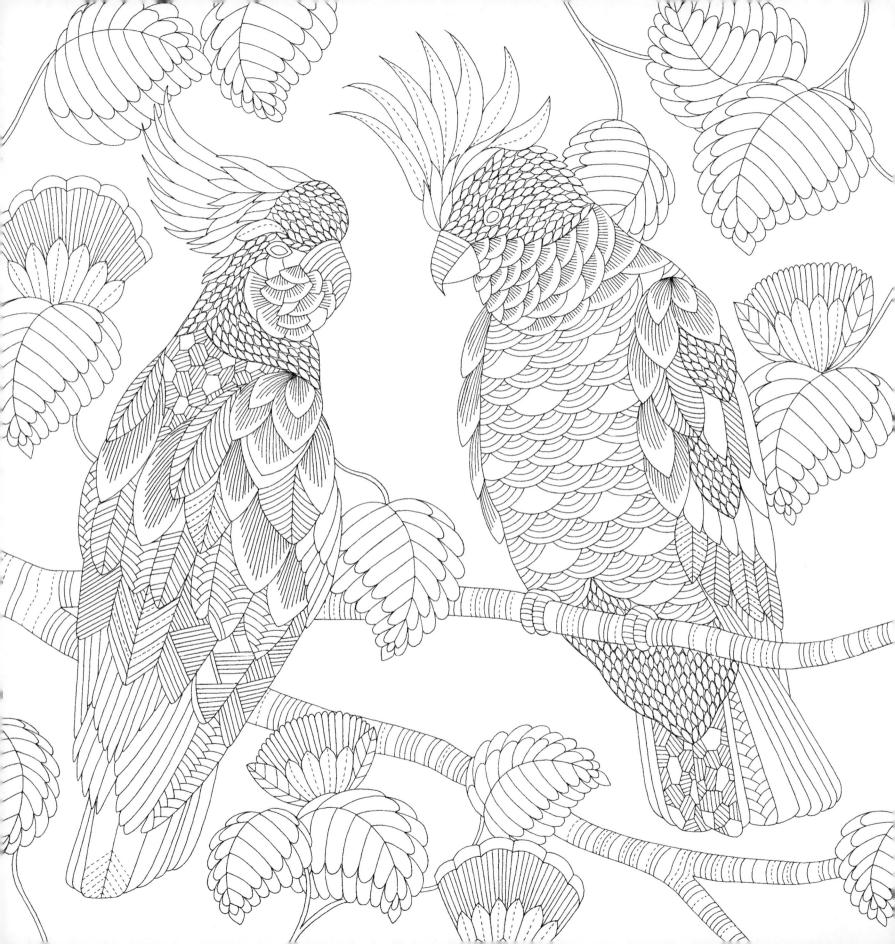

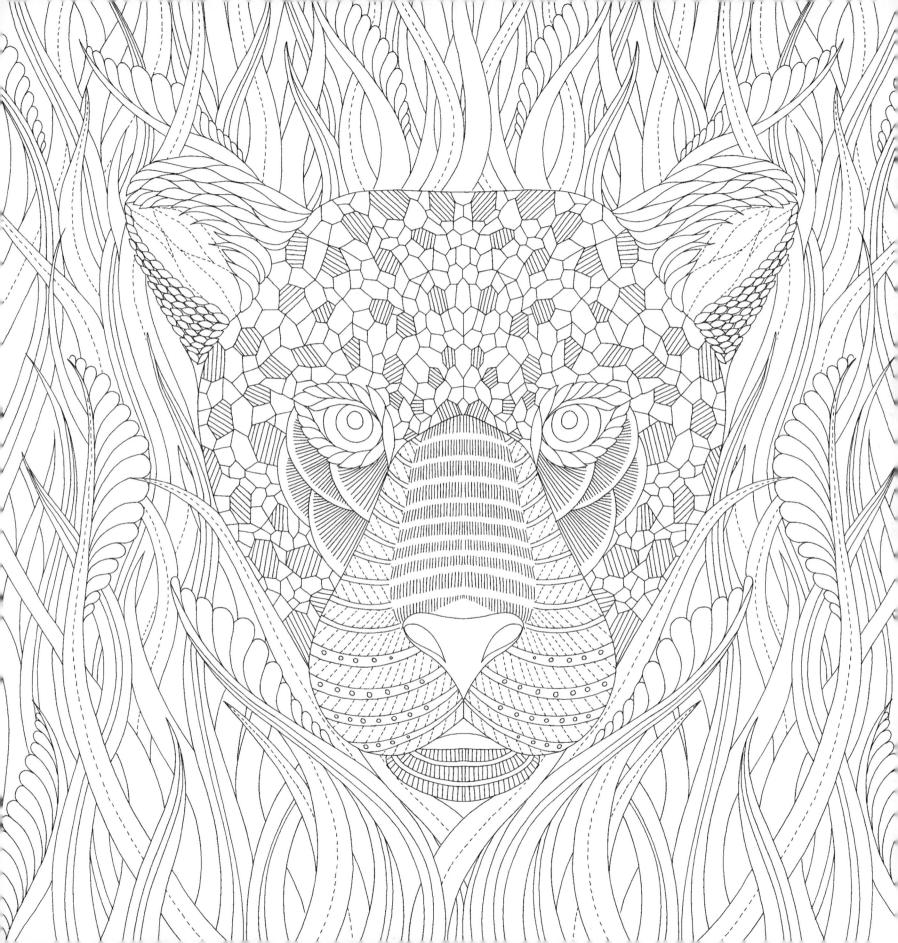

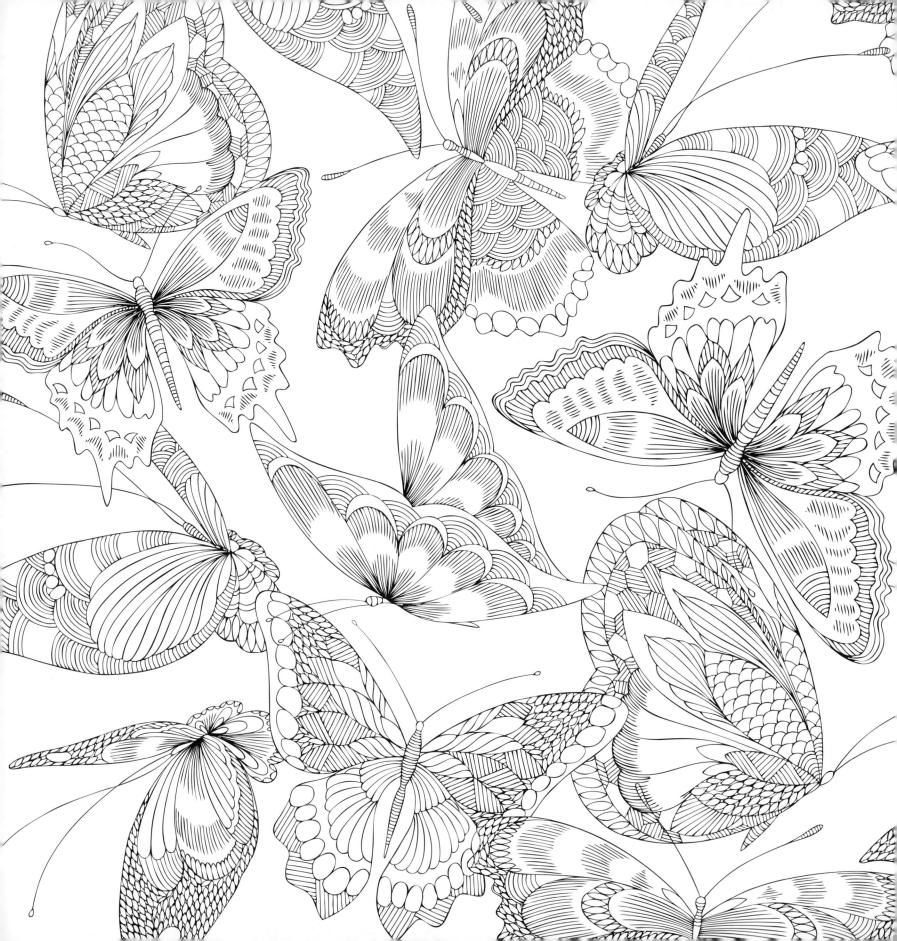

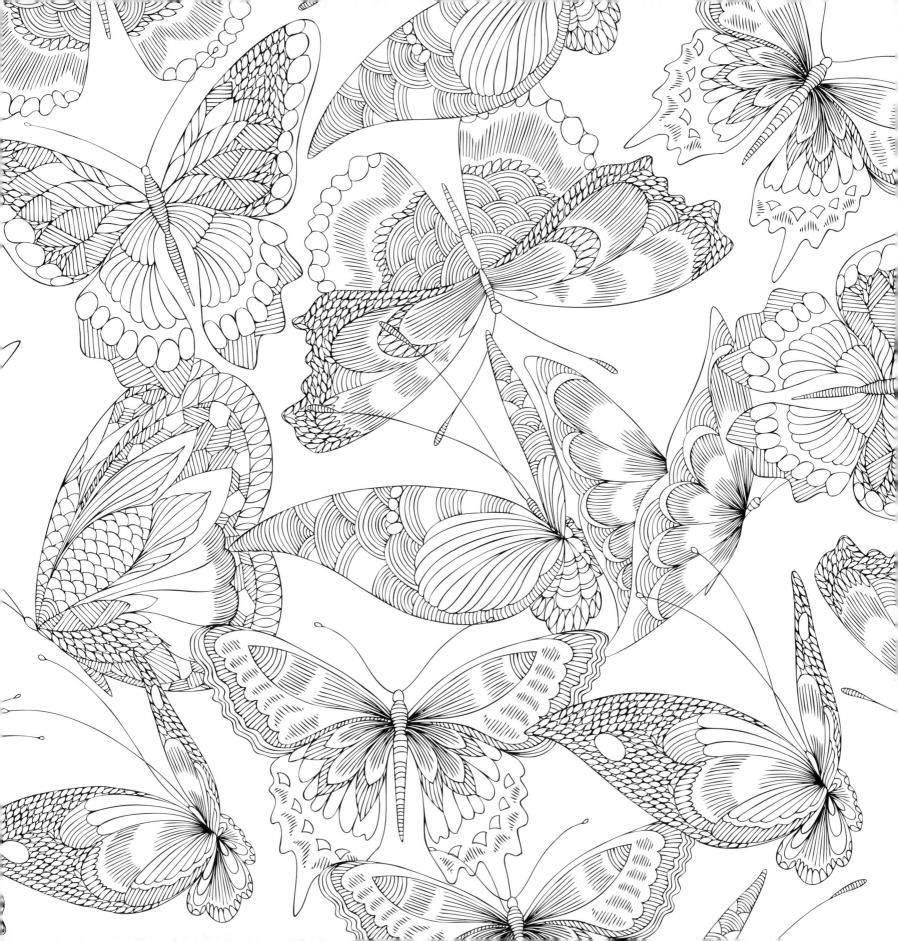

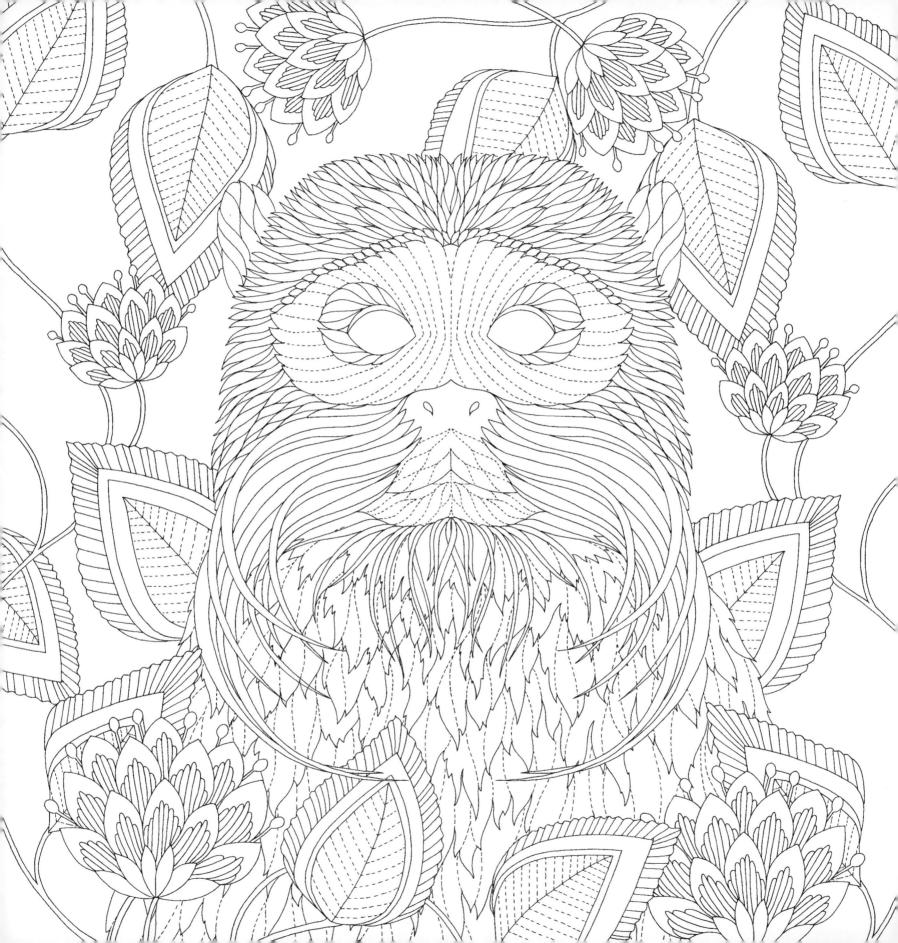

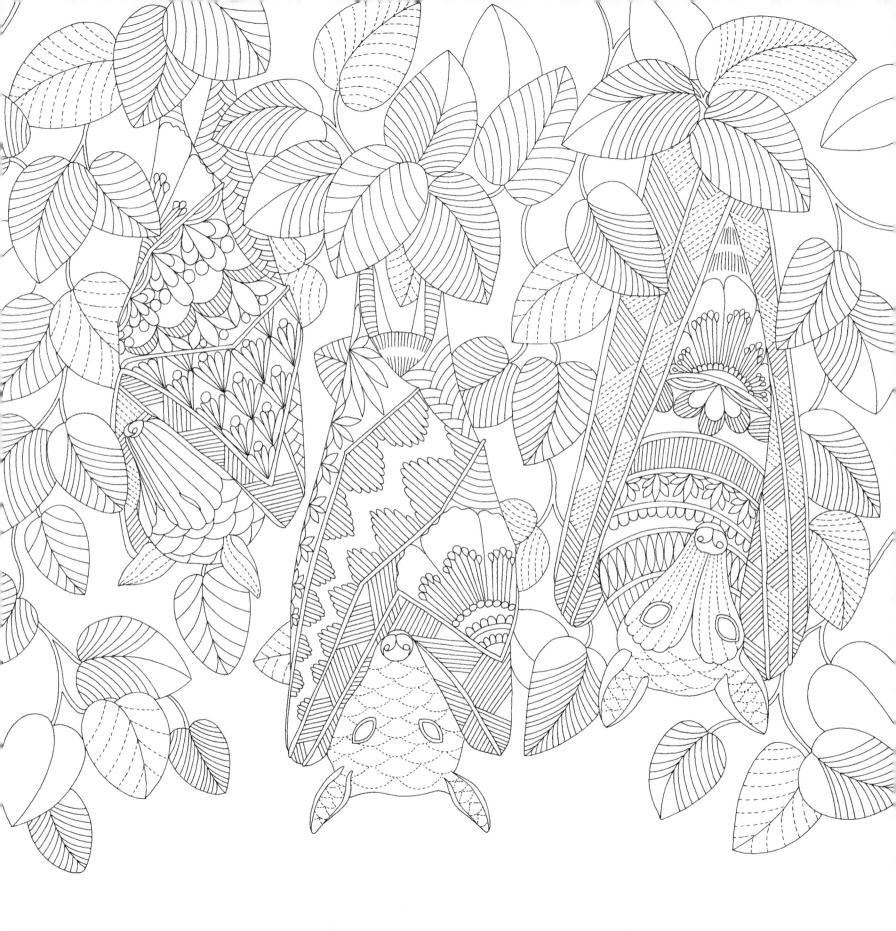

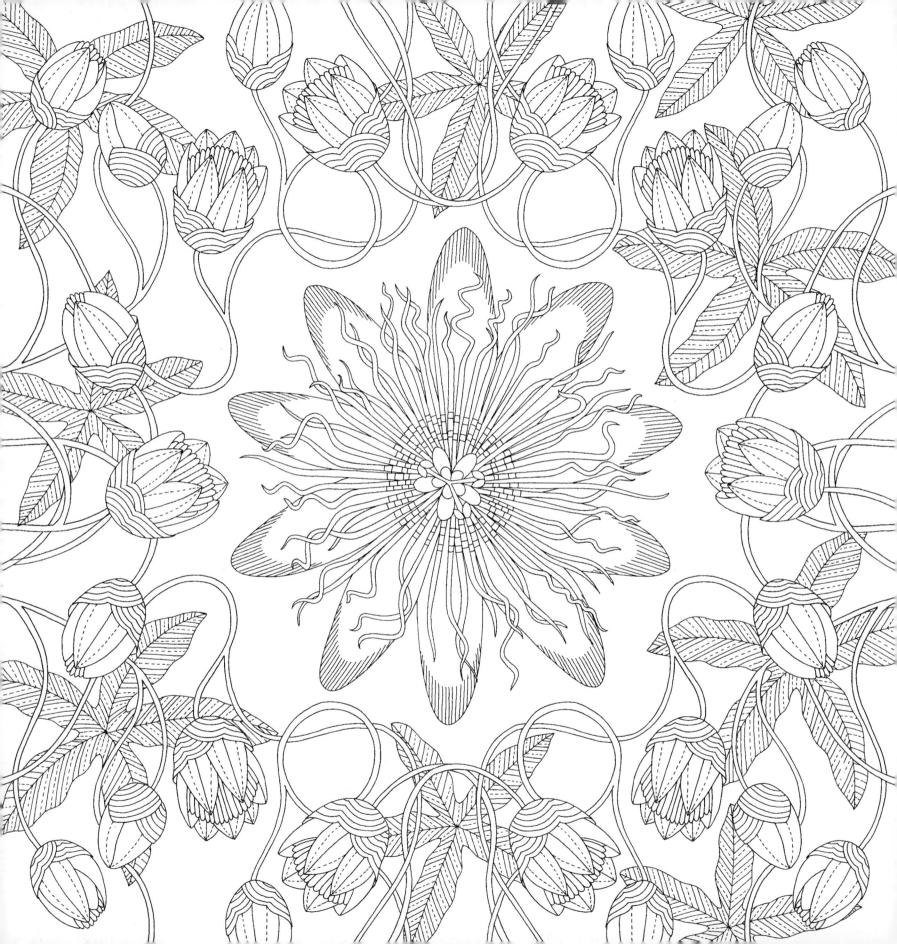

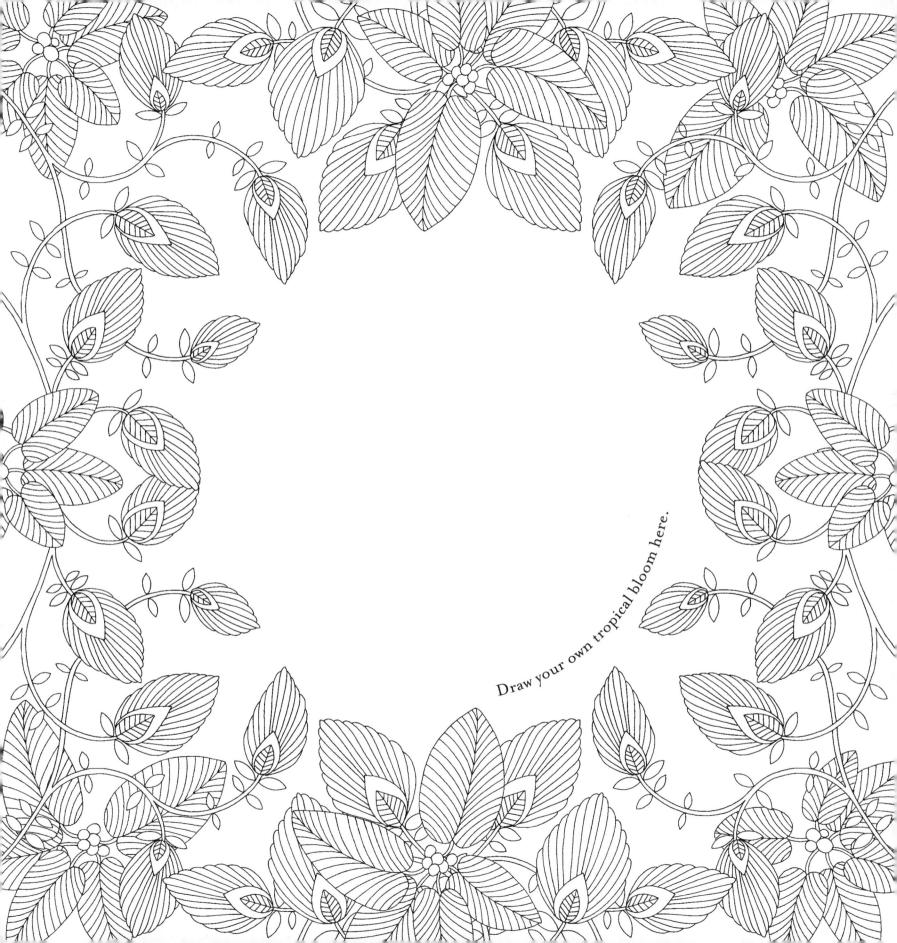

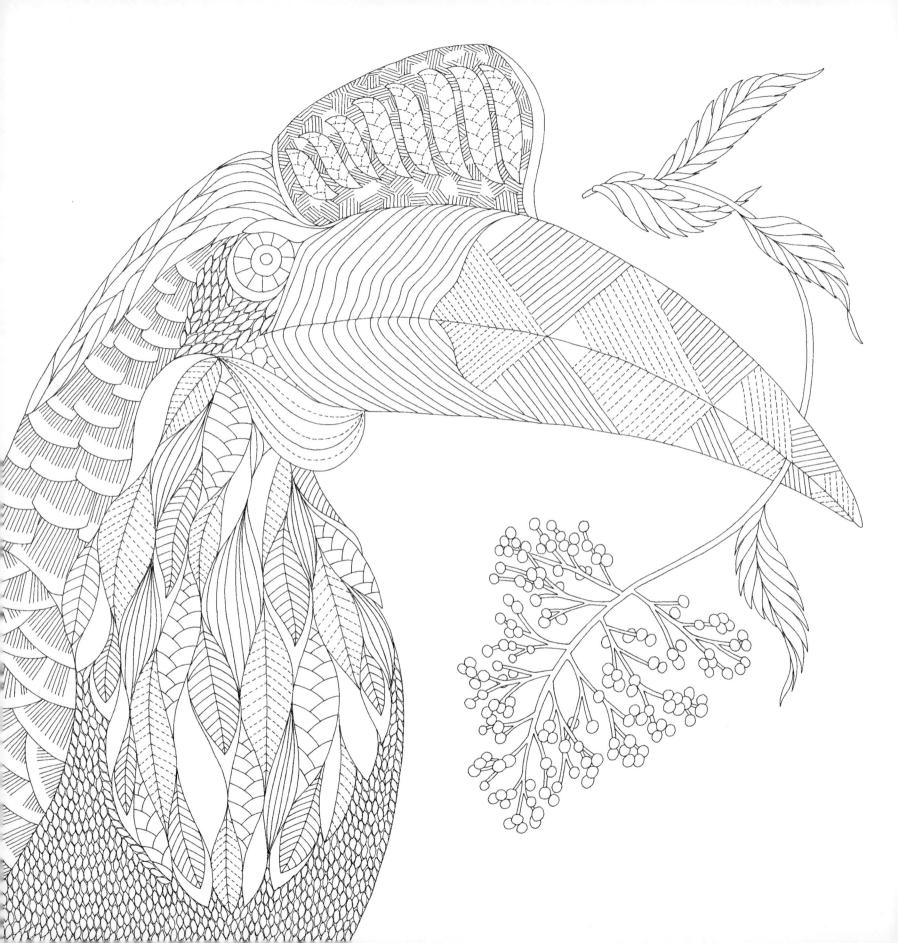

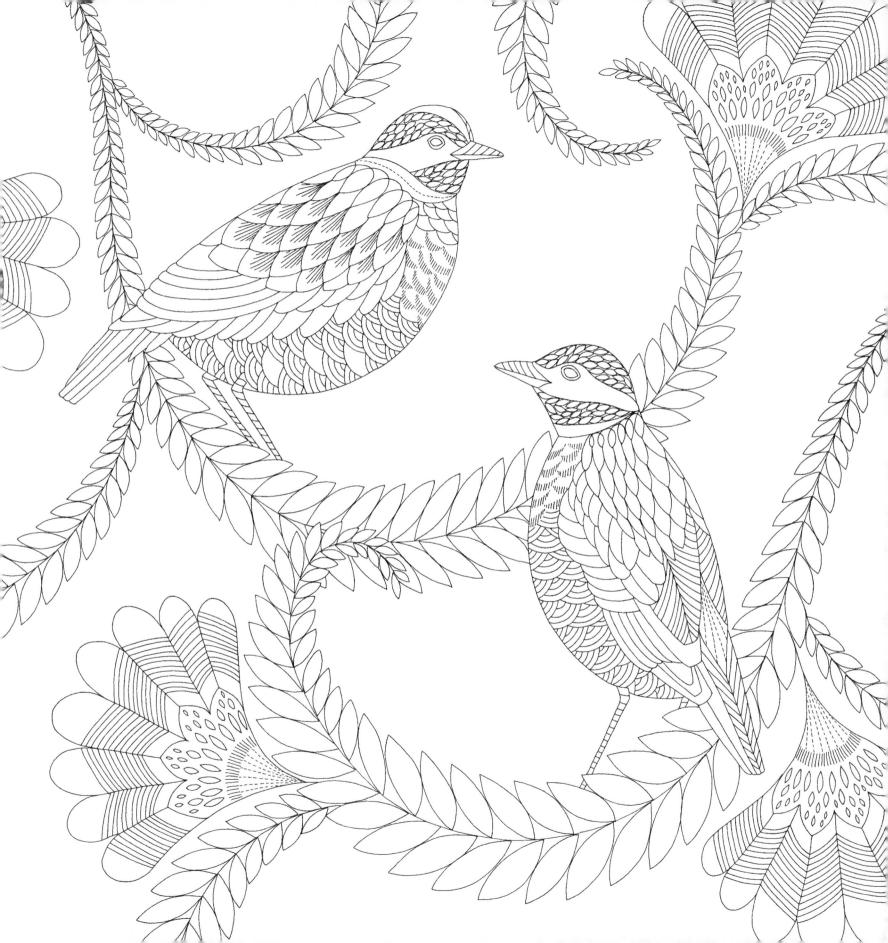

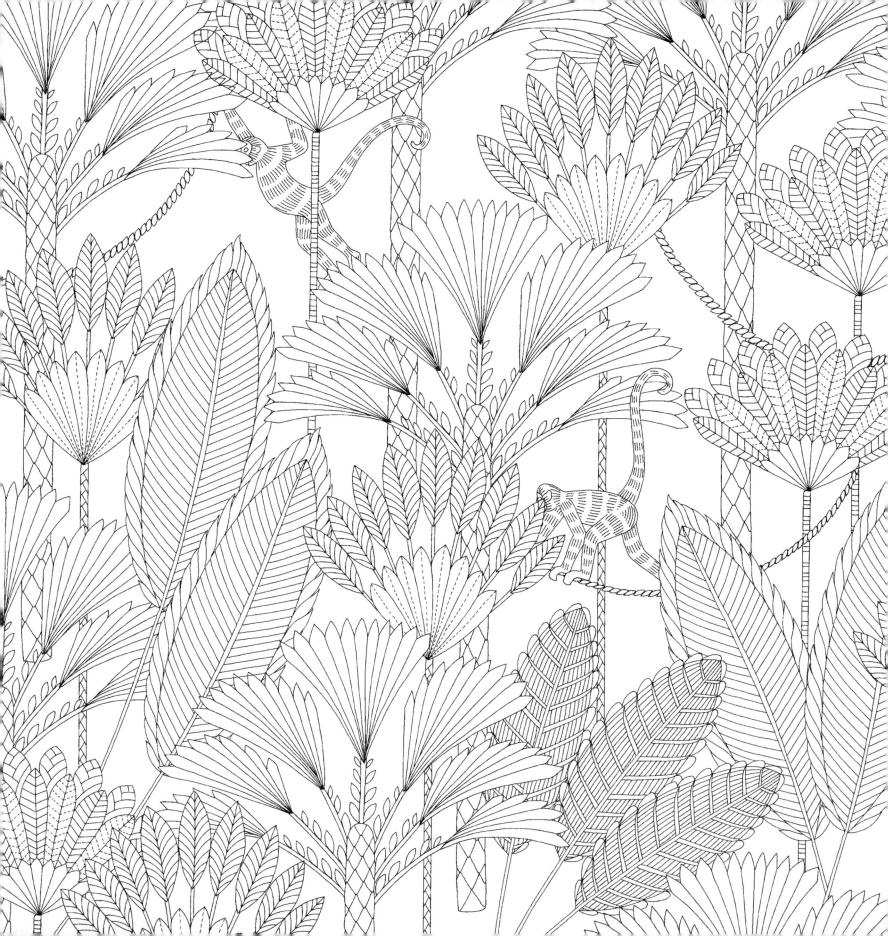

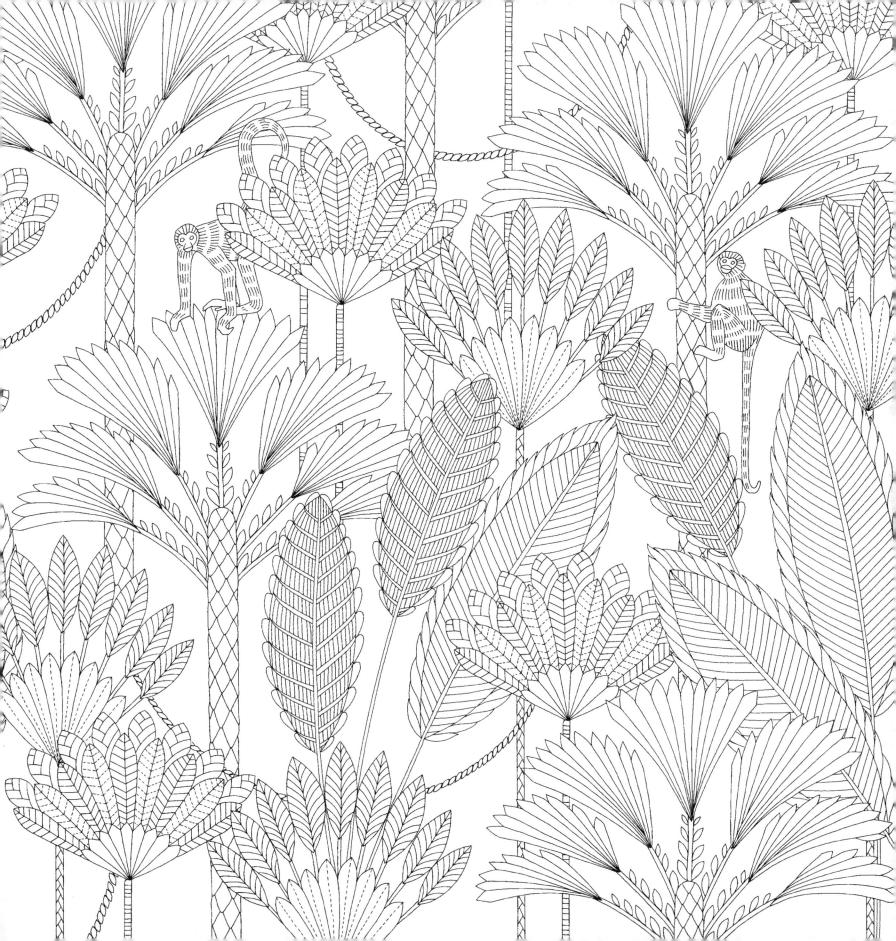

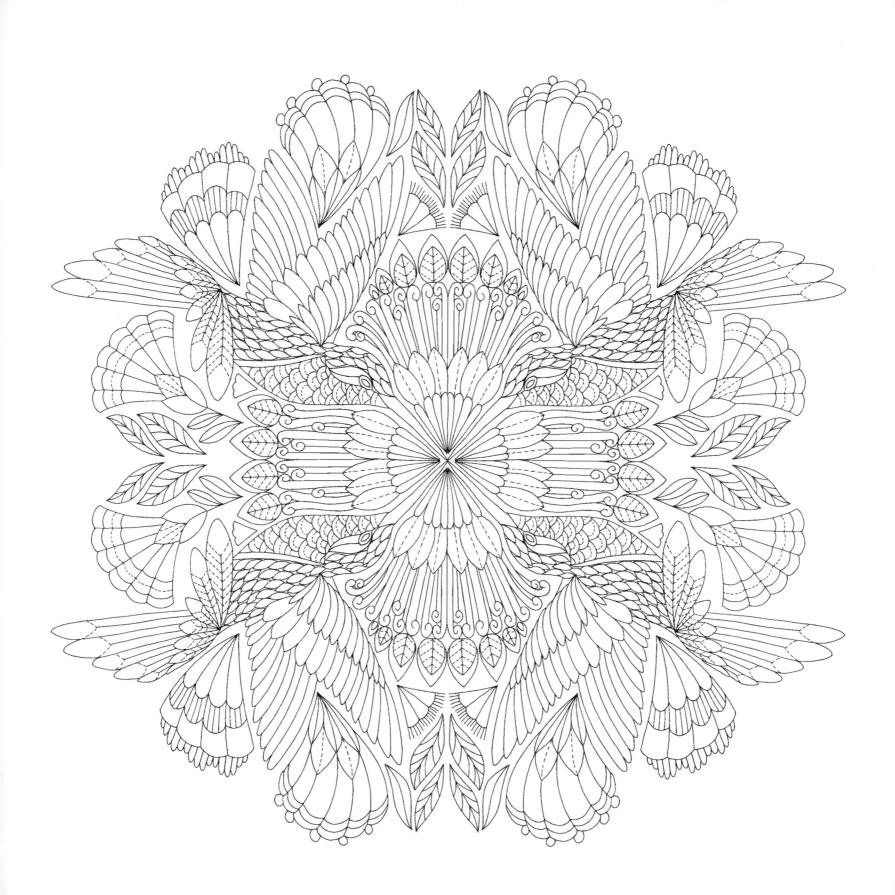

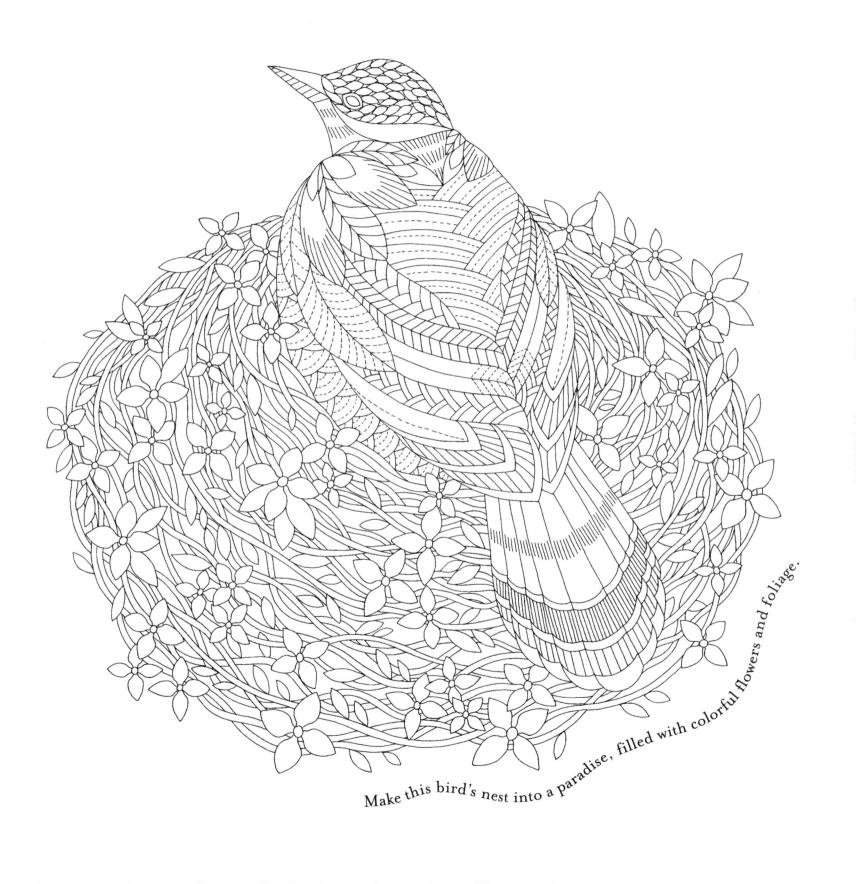

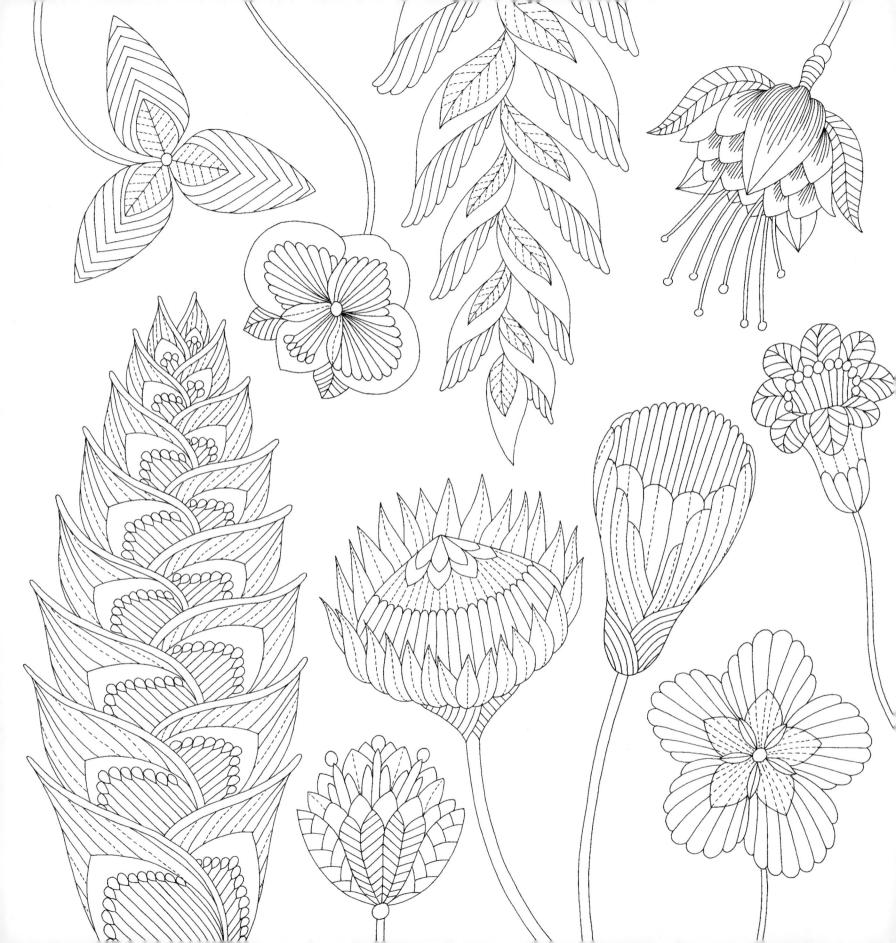

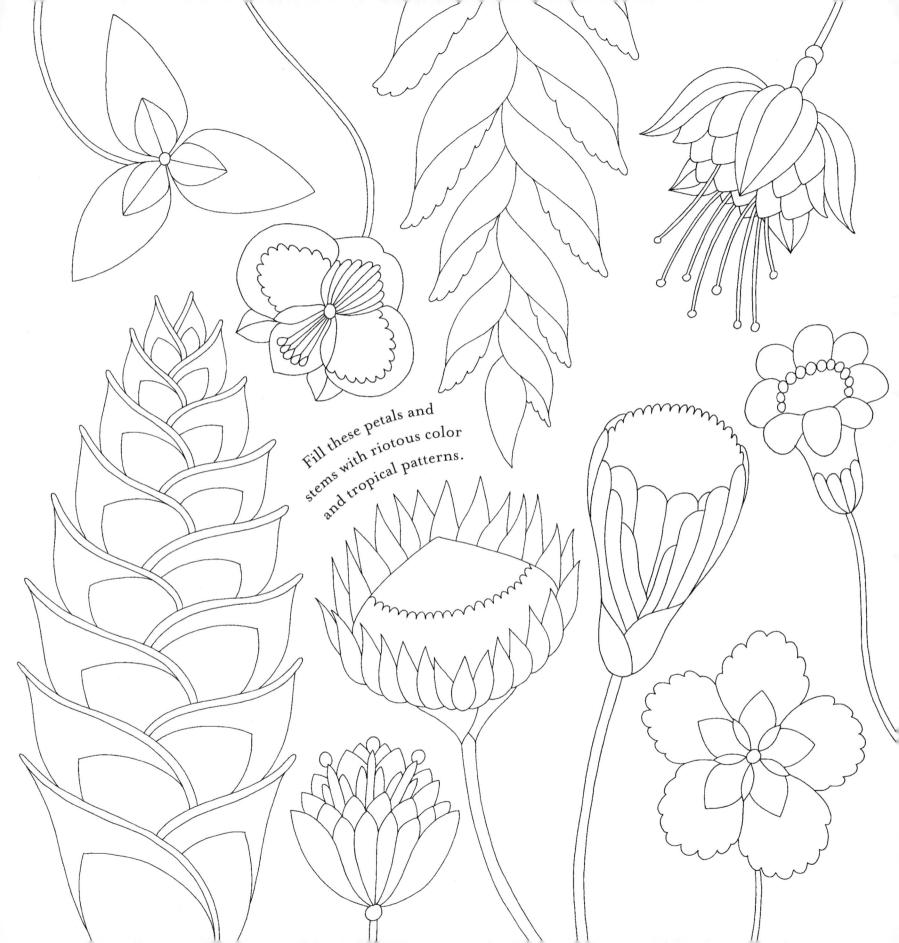

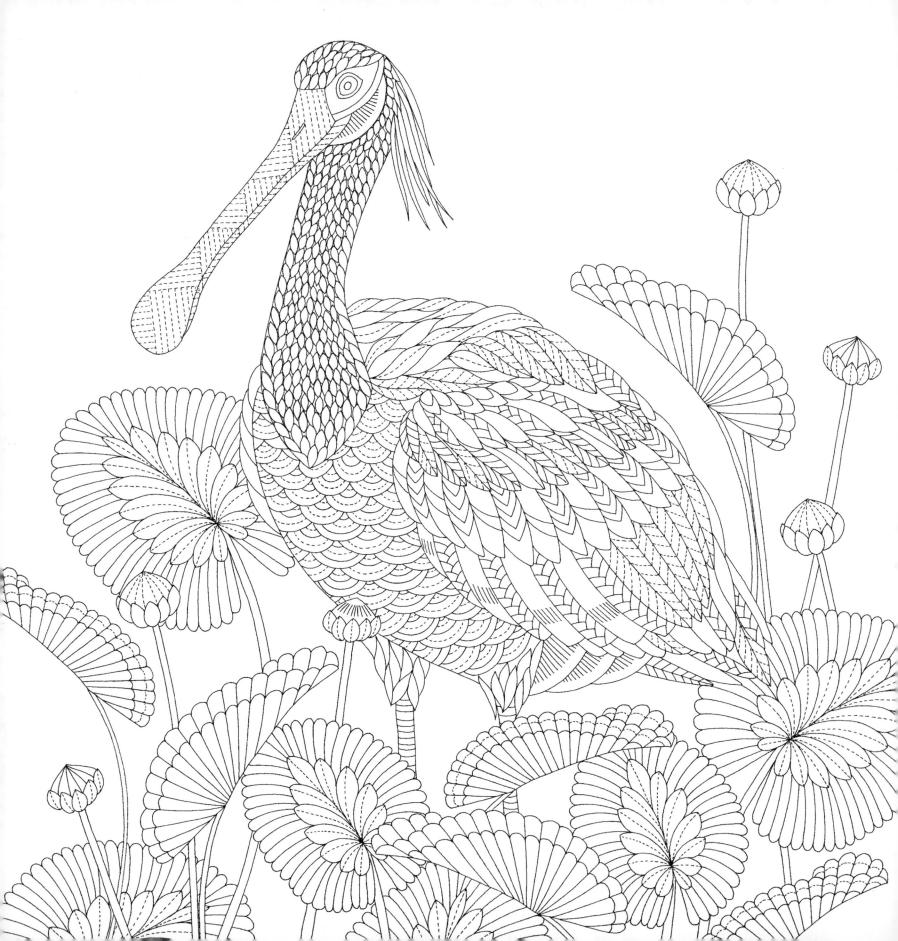

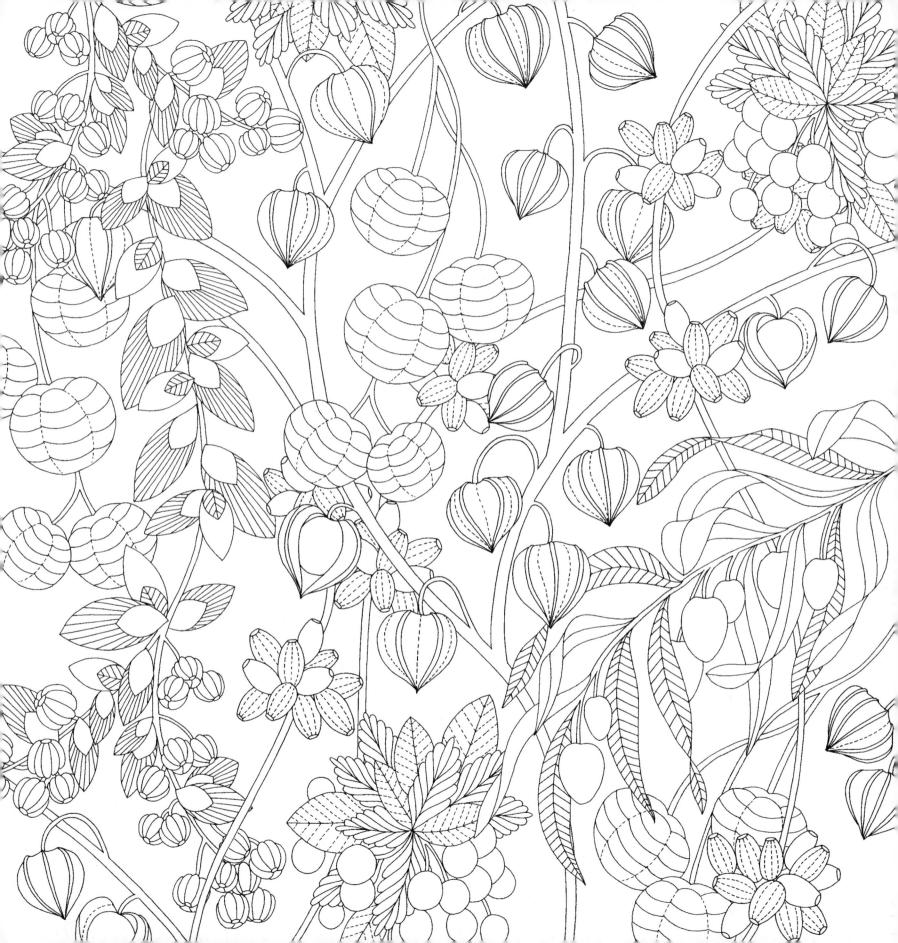

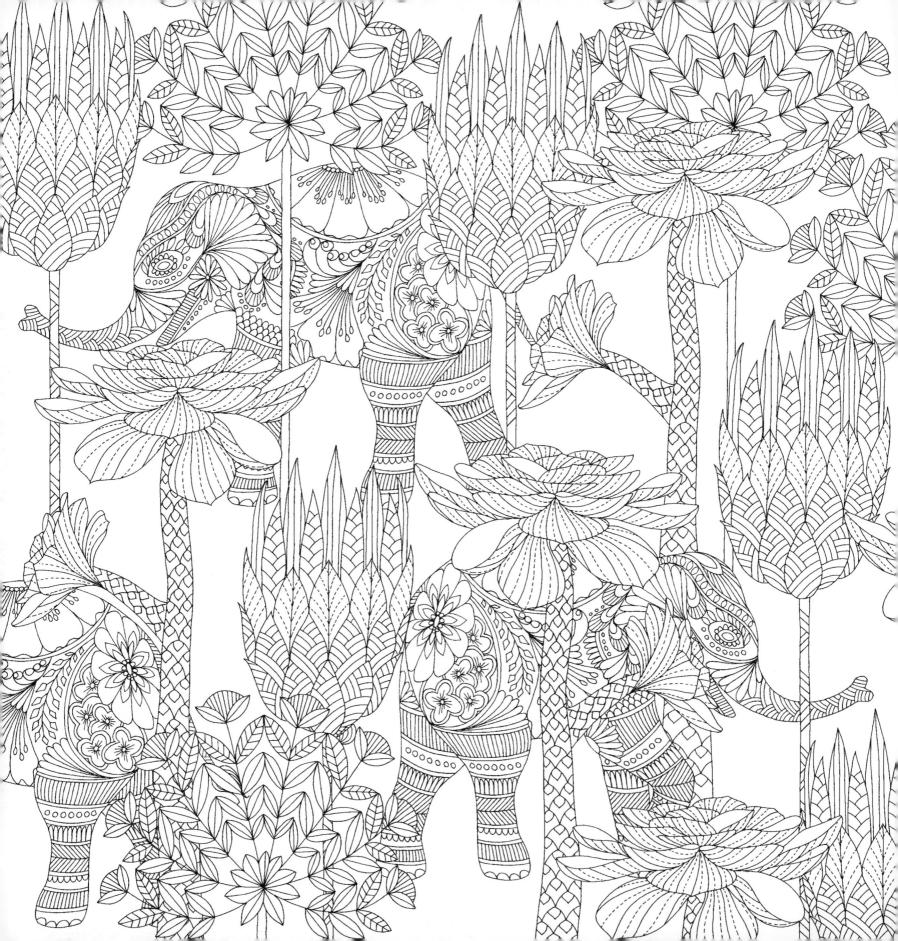

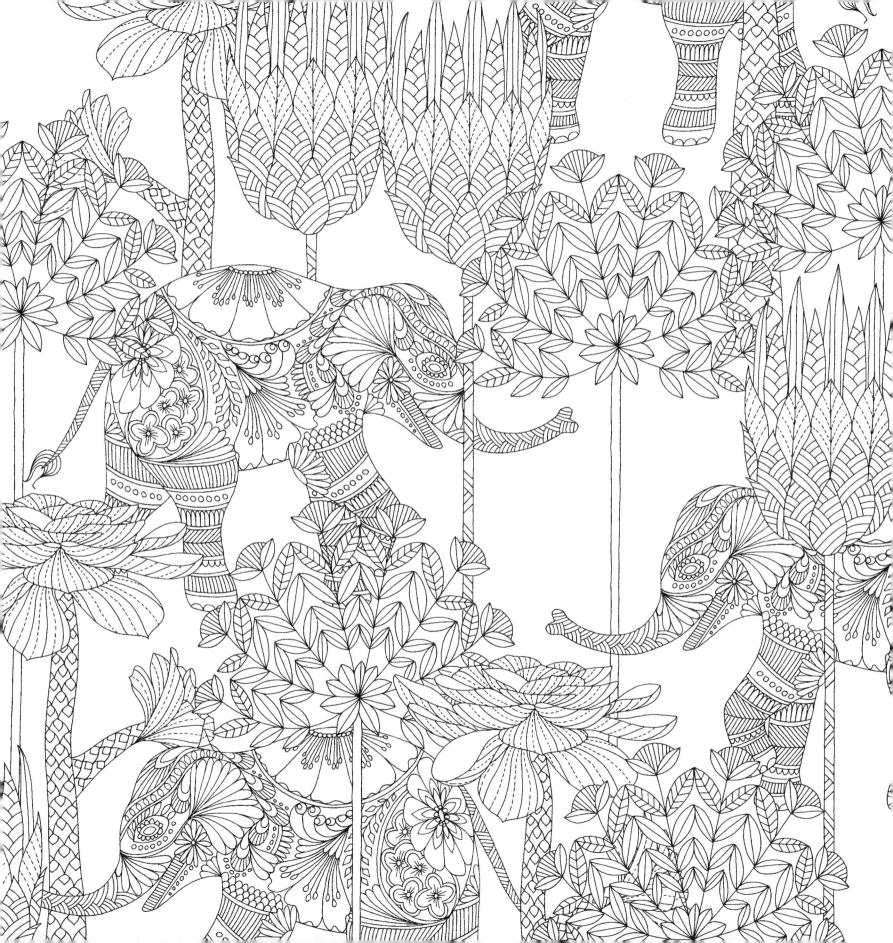

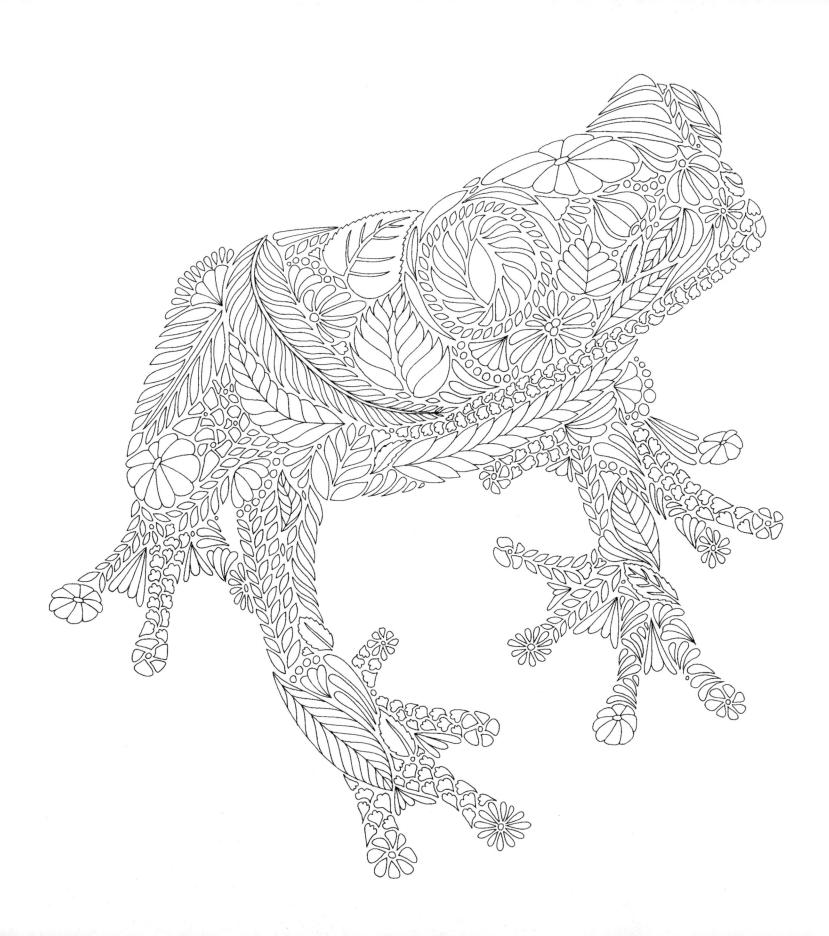

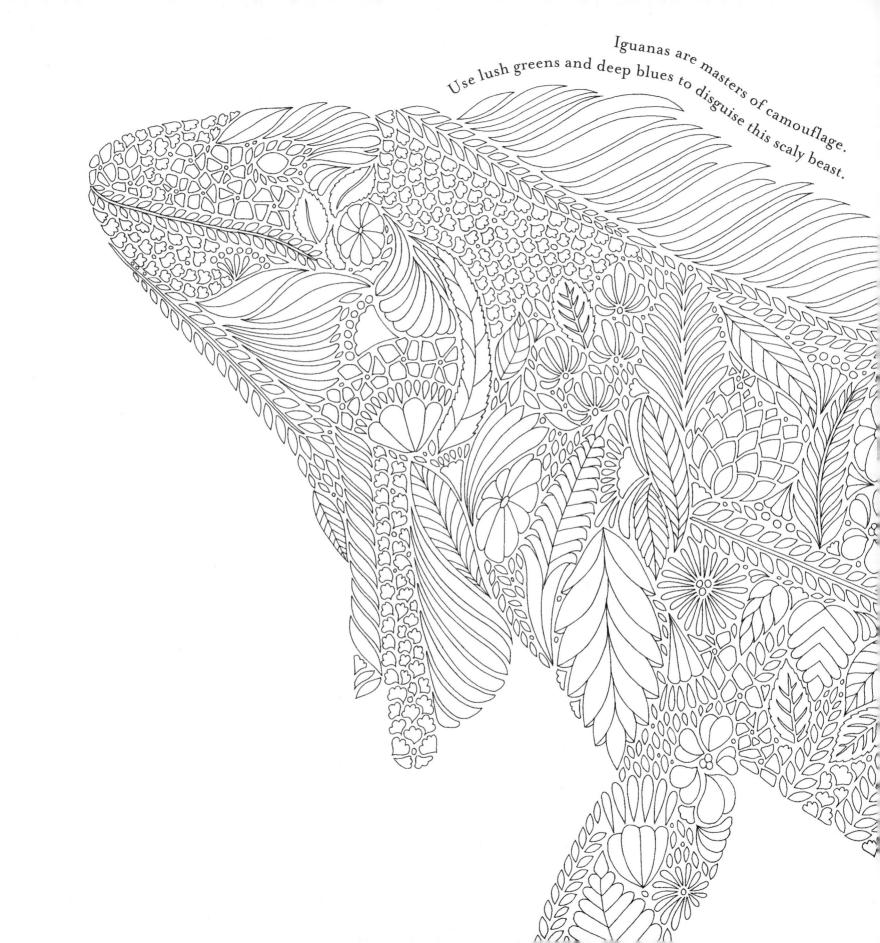

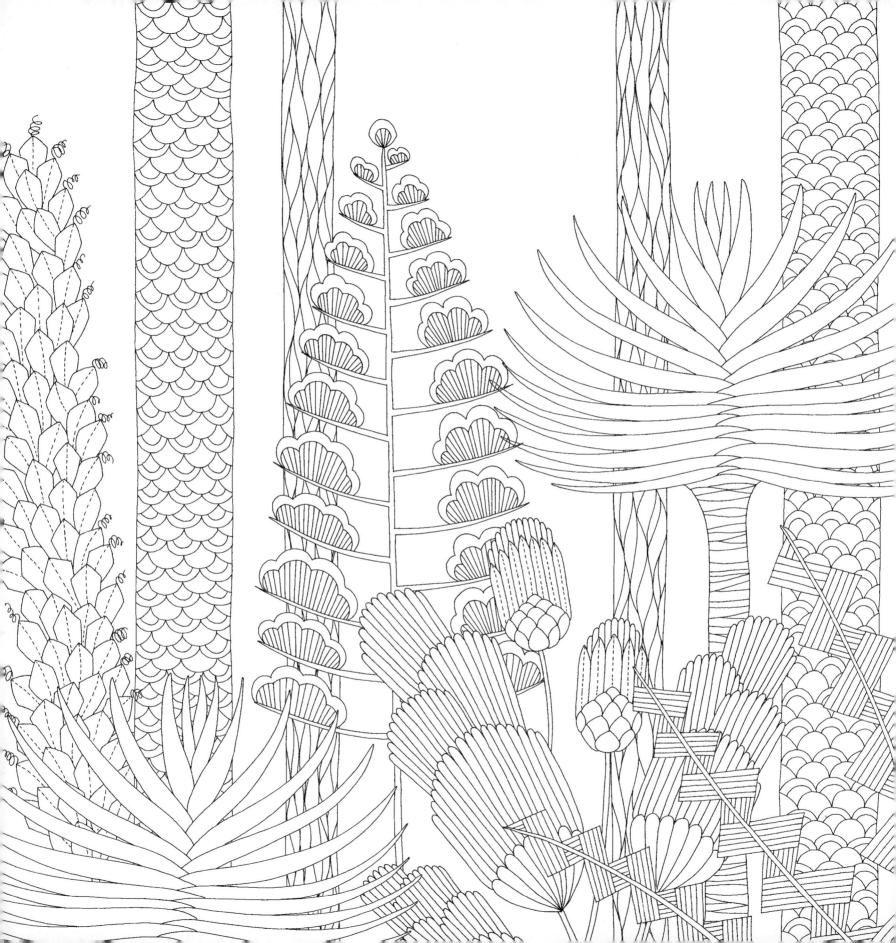

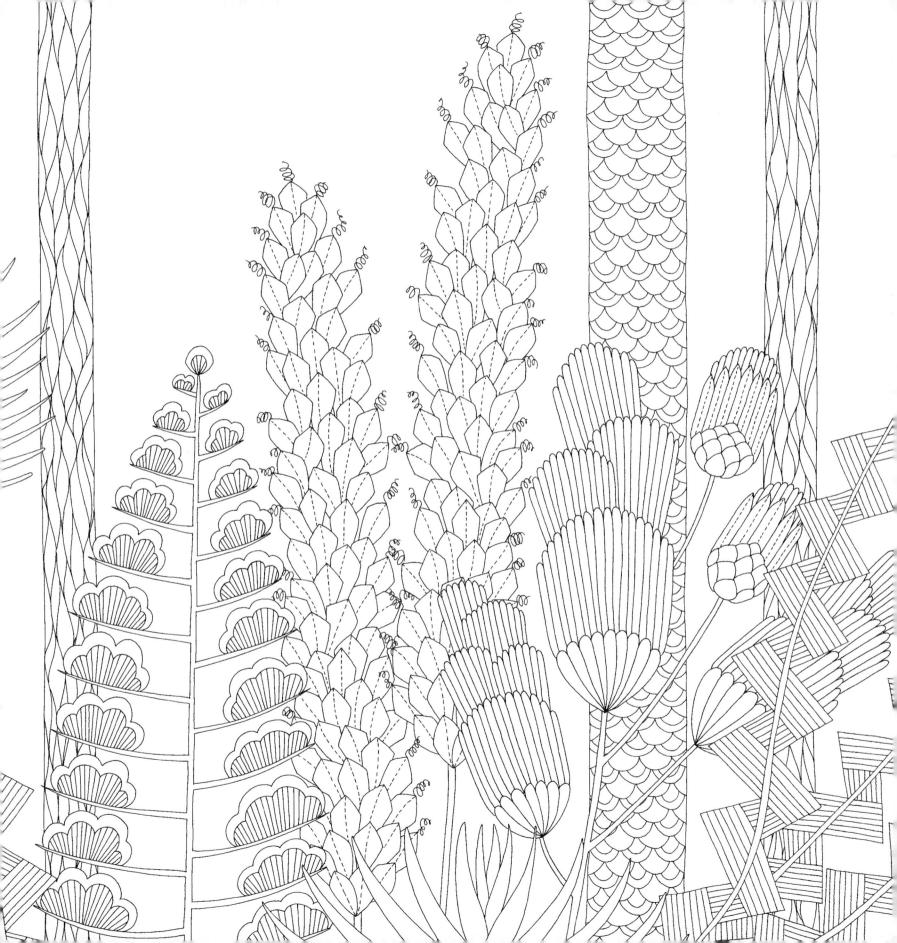

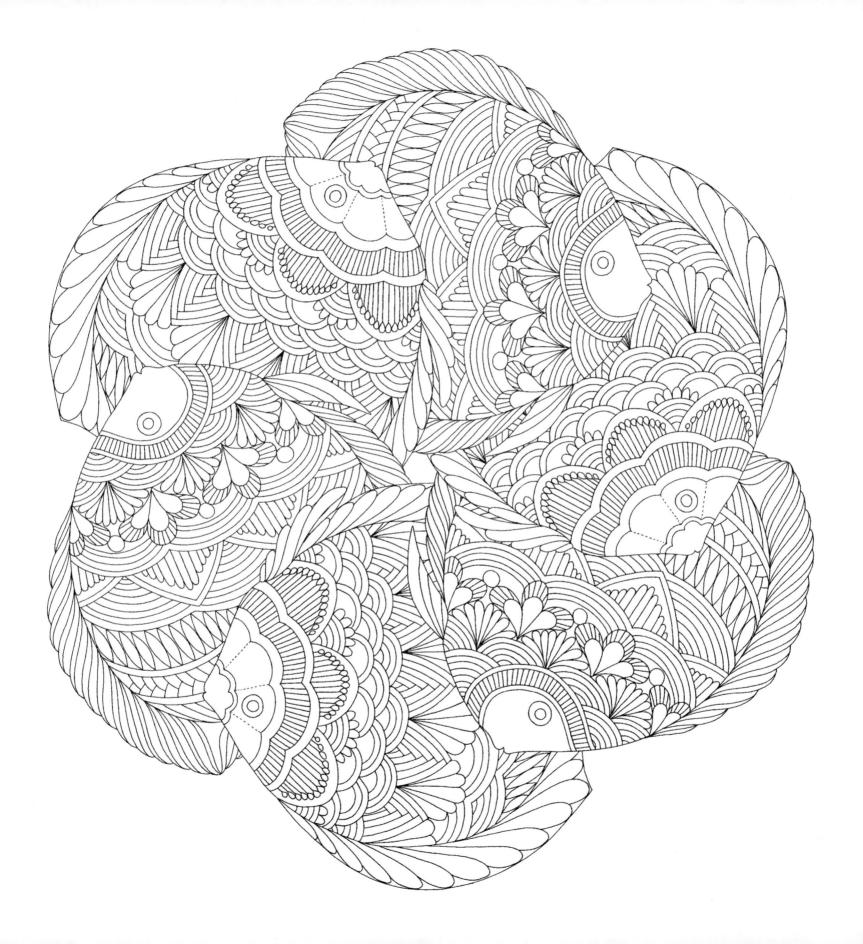

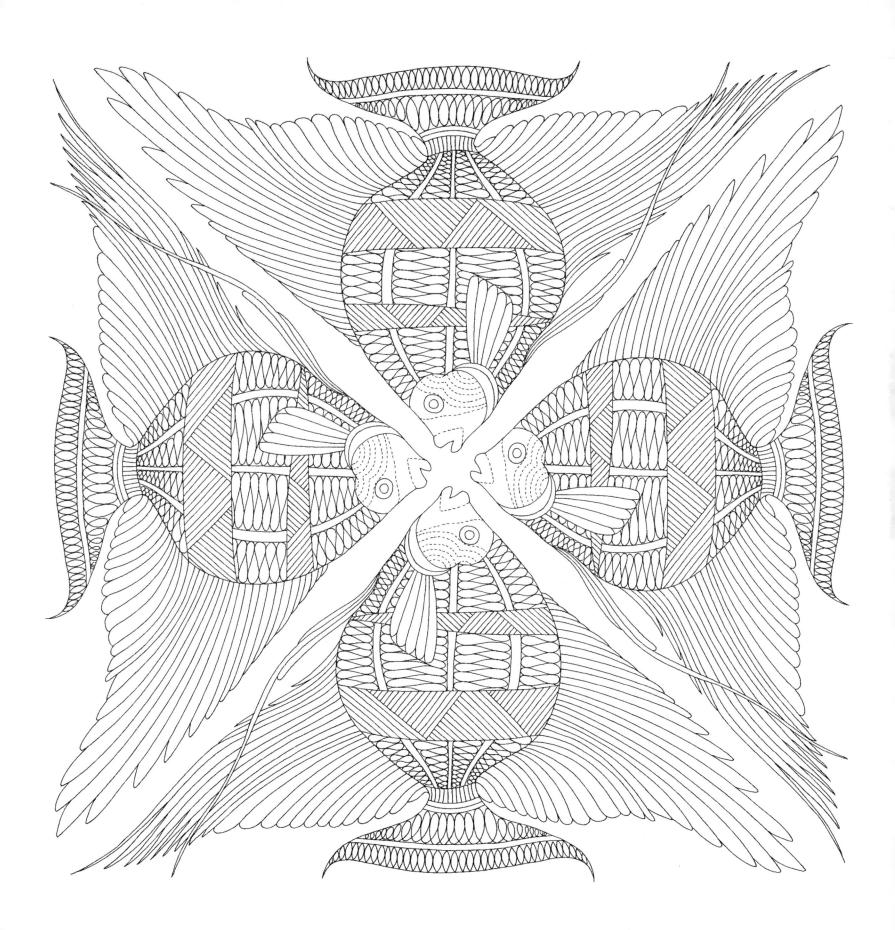

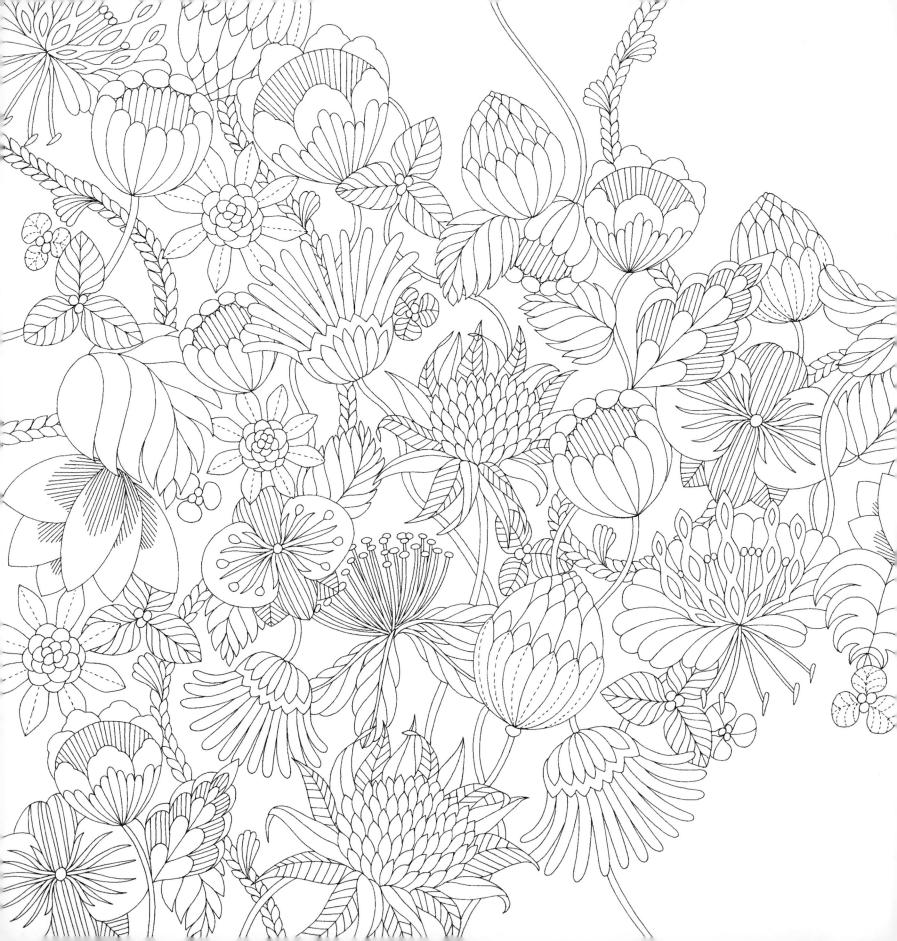

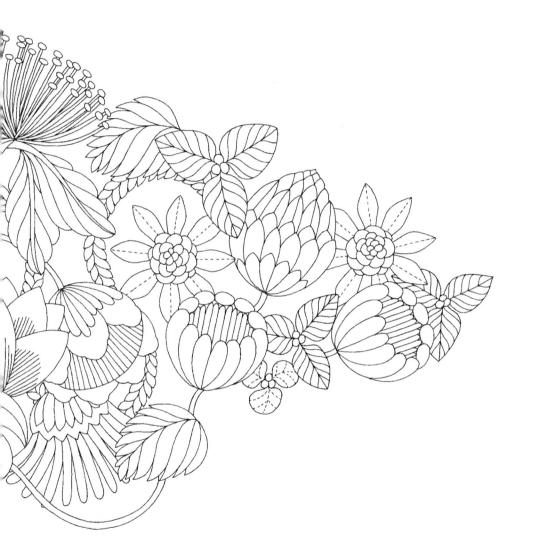

Rainforests are bursting with life. Complete the drawing with your own tropical flora.

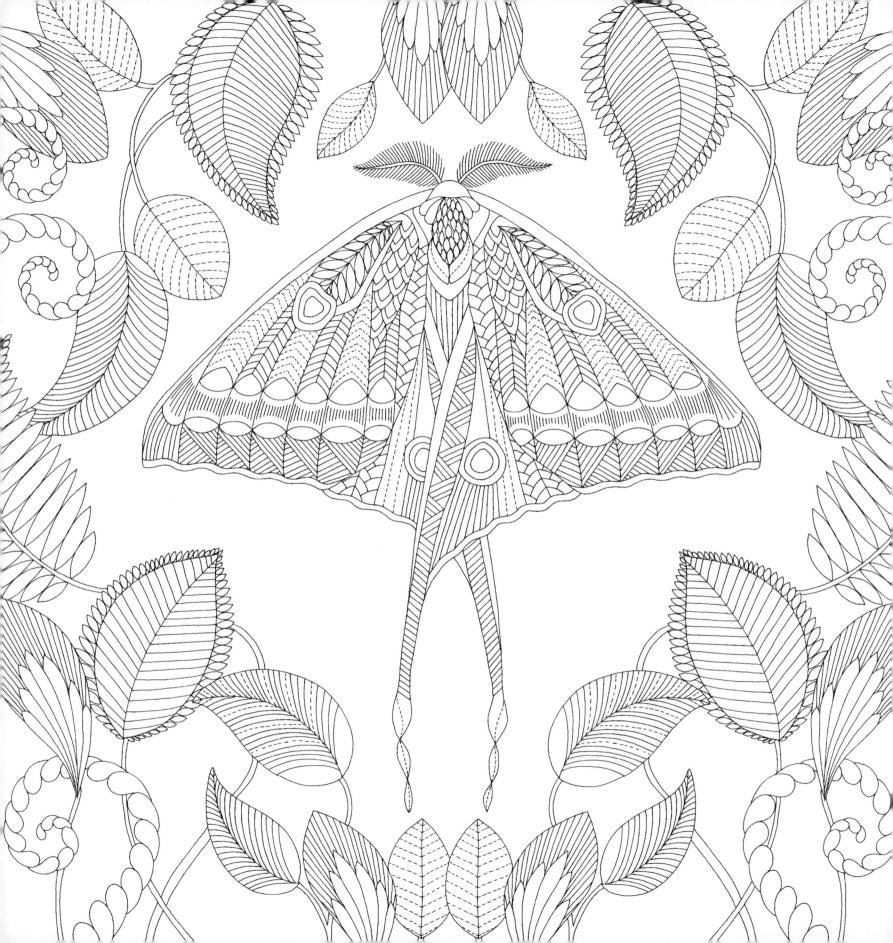

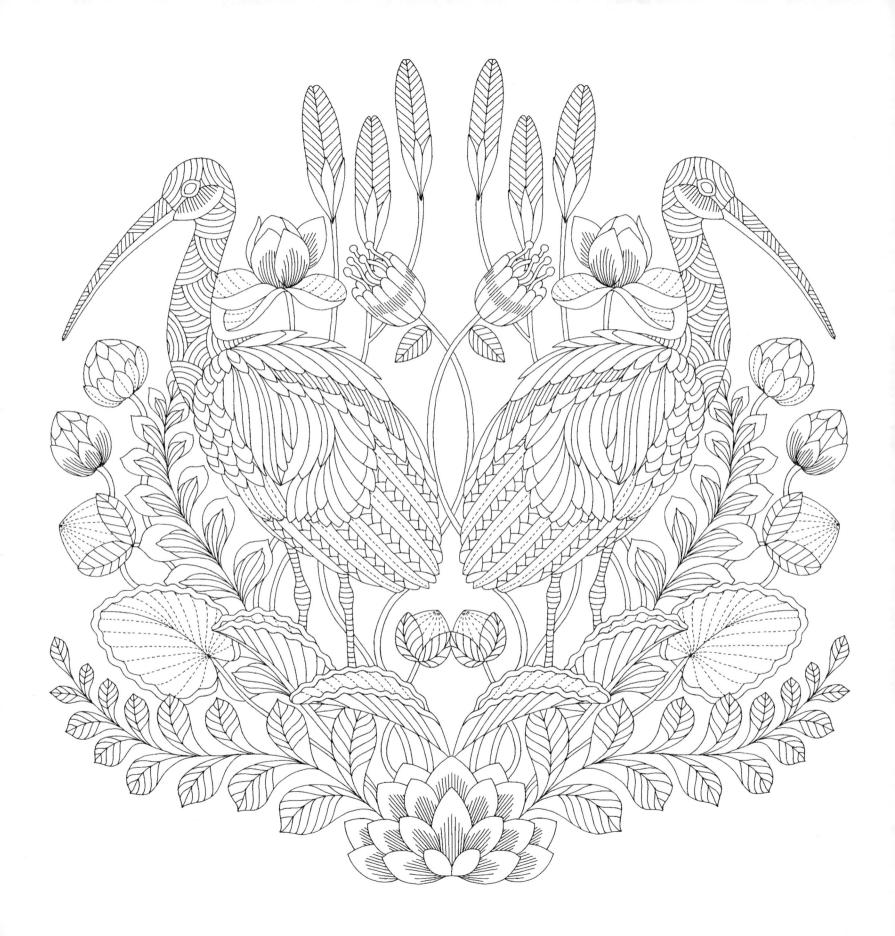

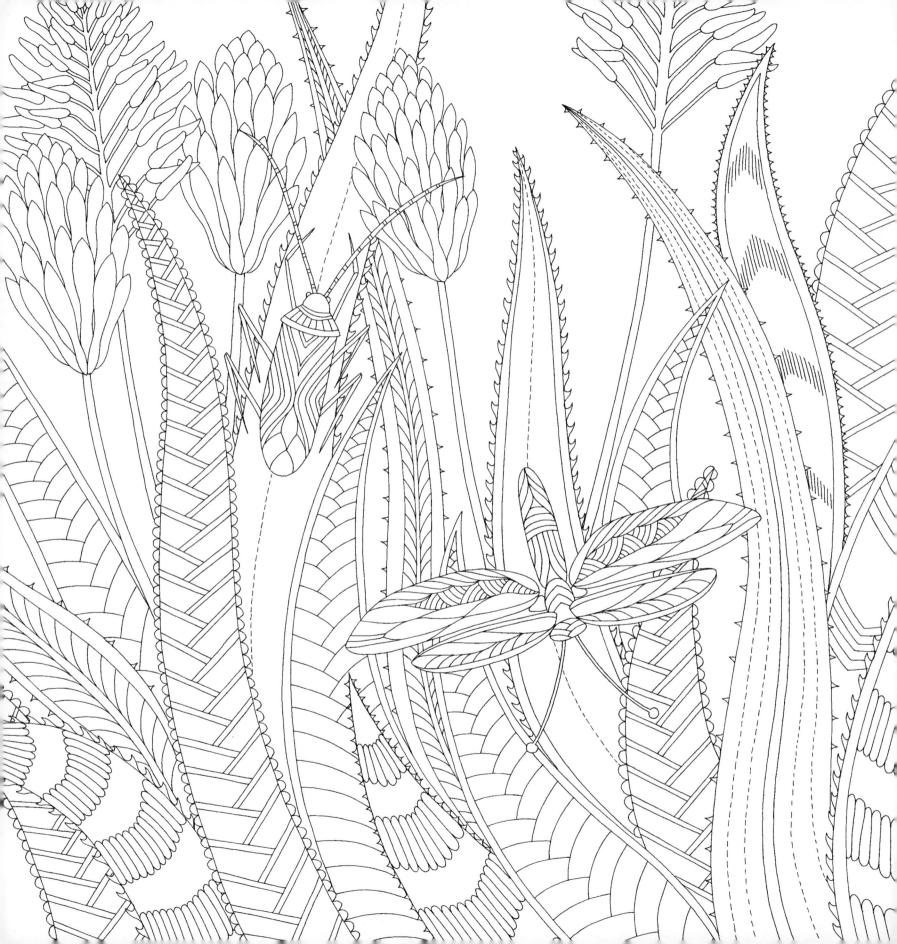

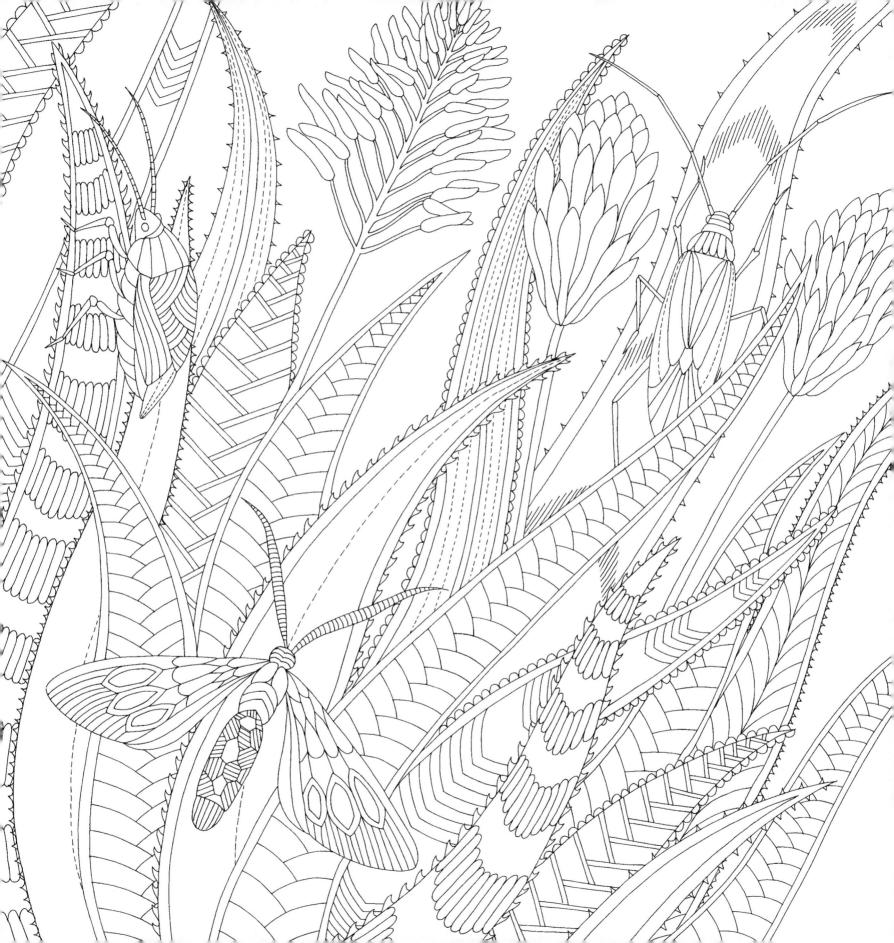

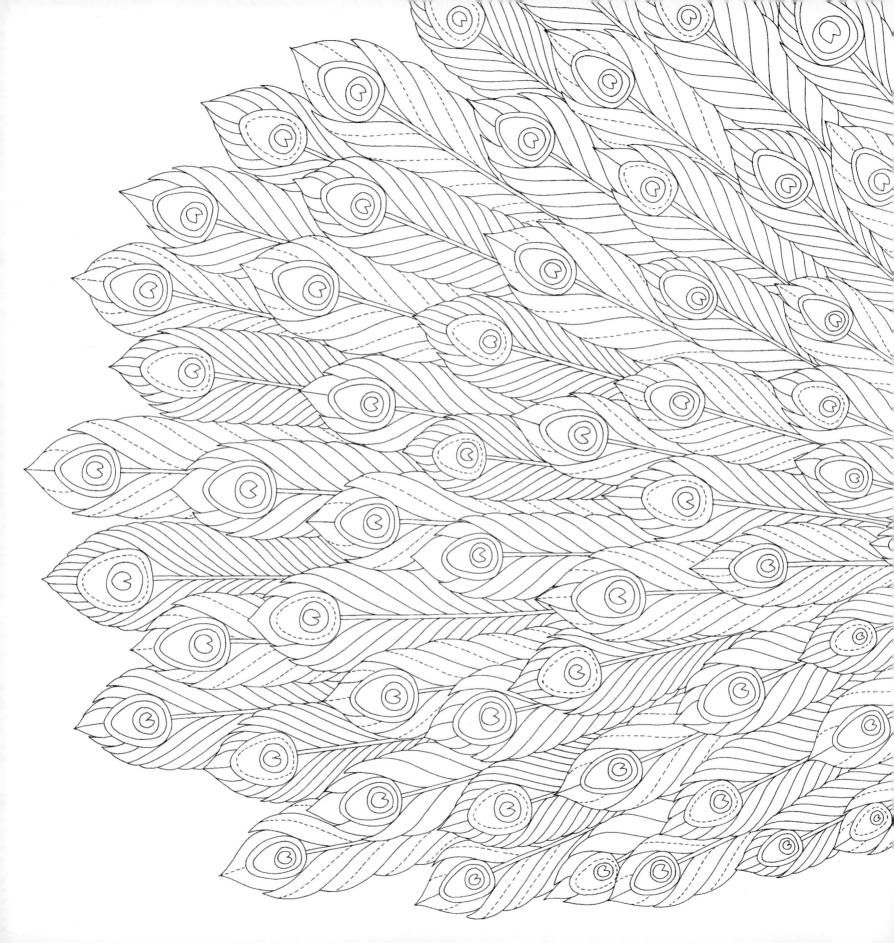

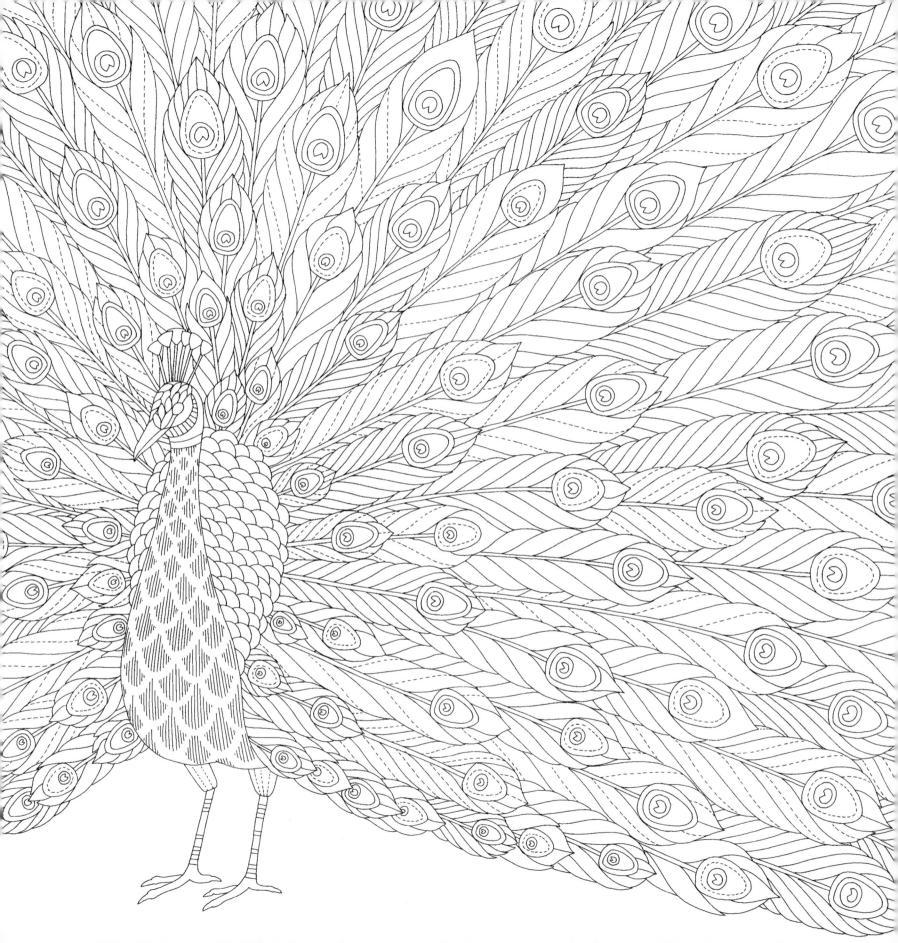

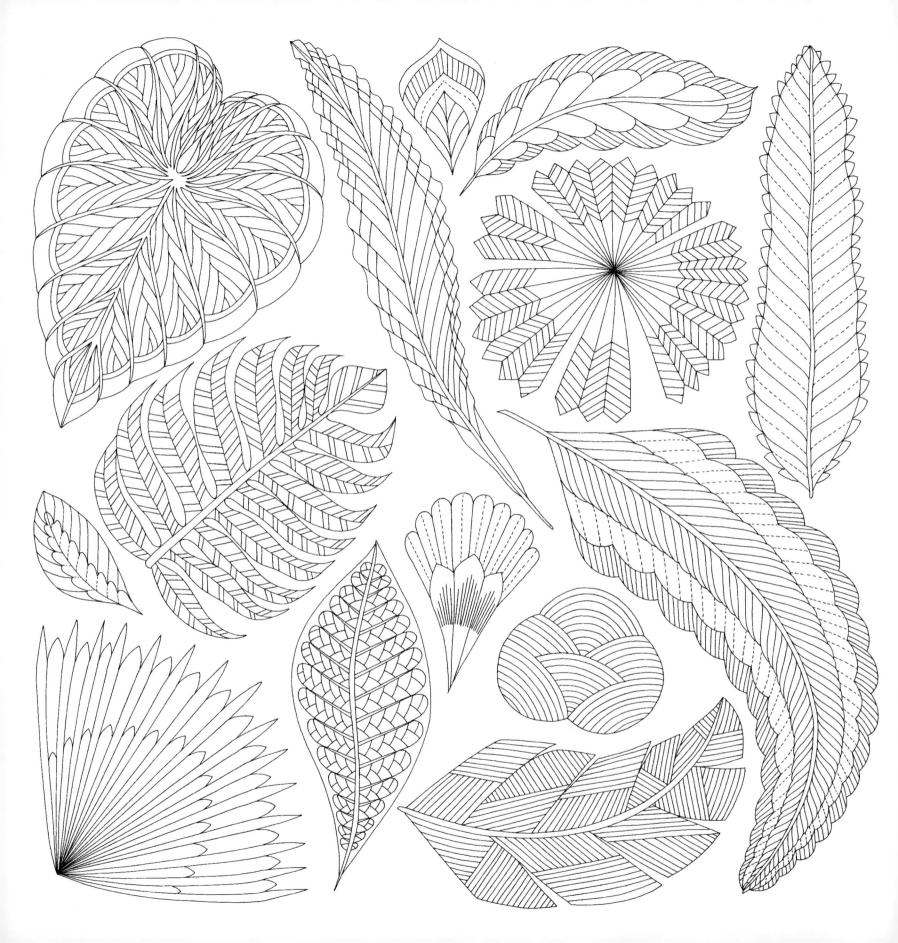

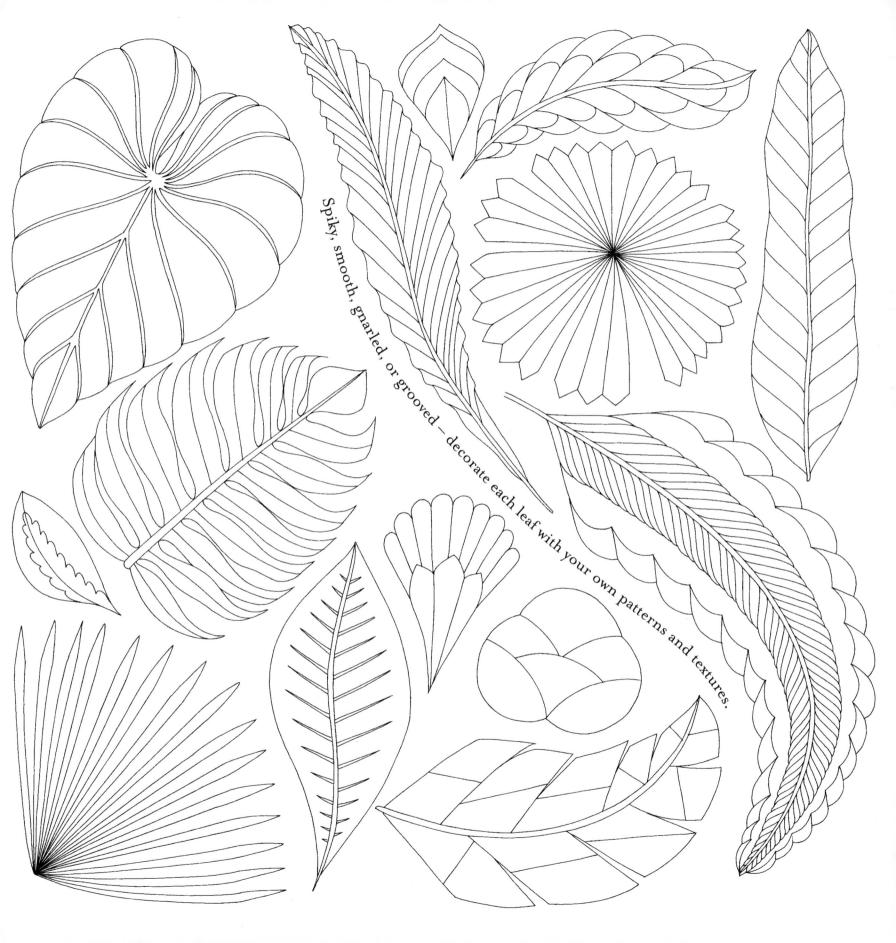

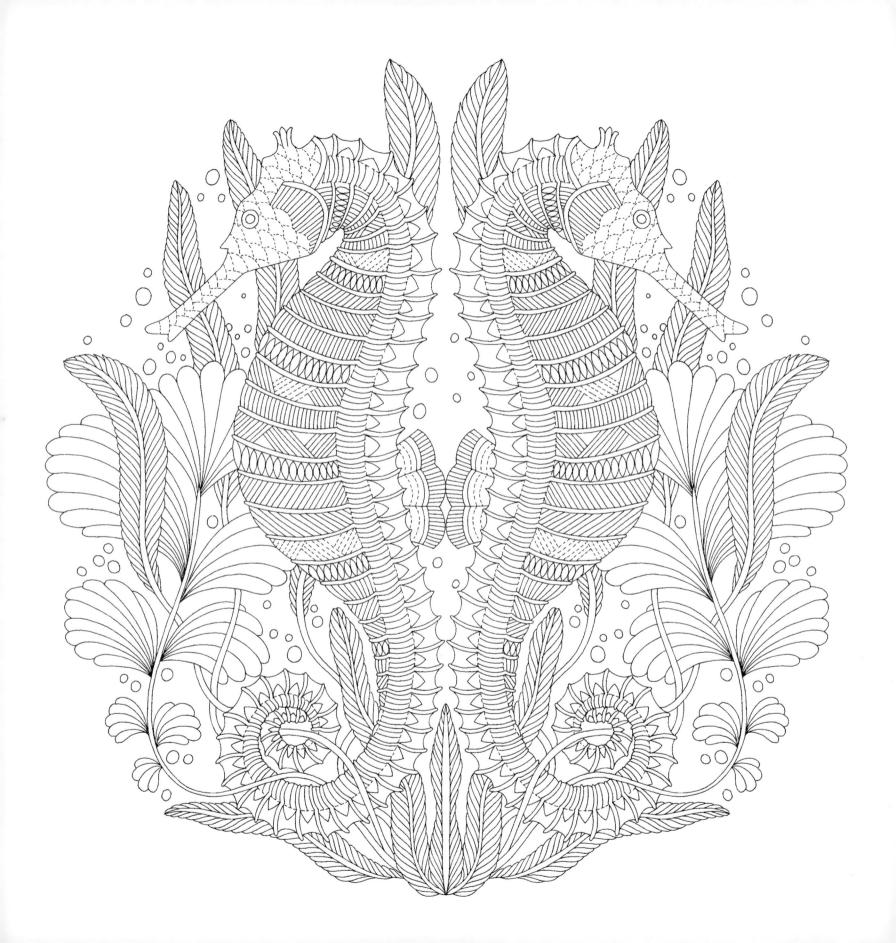

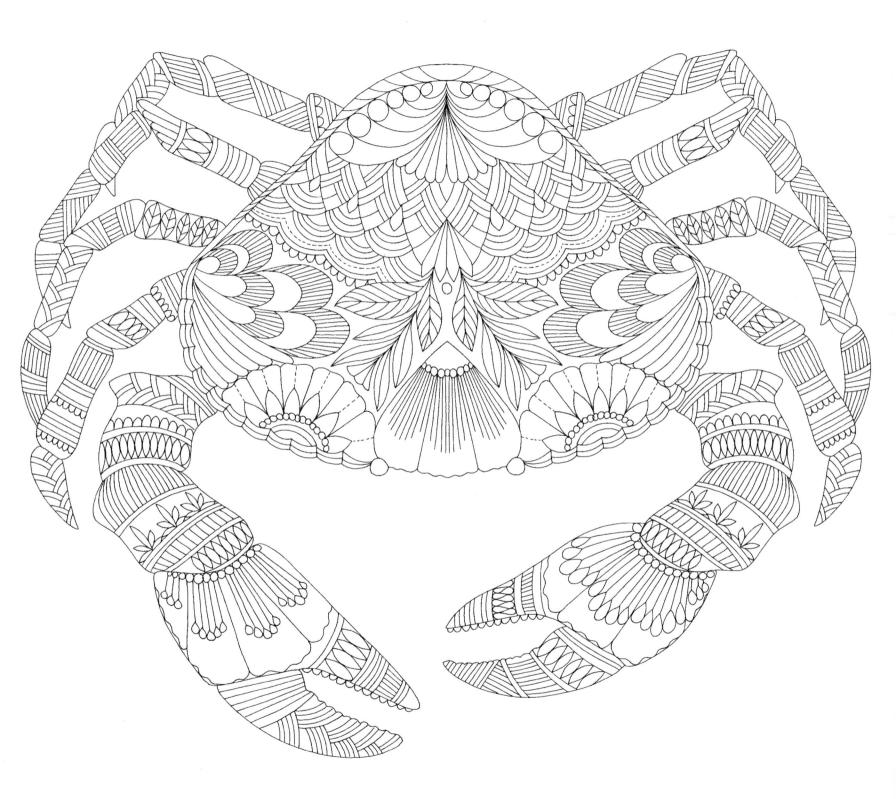

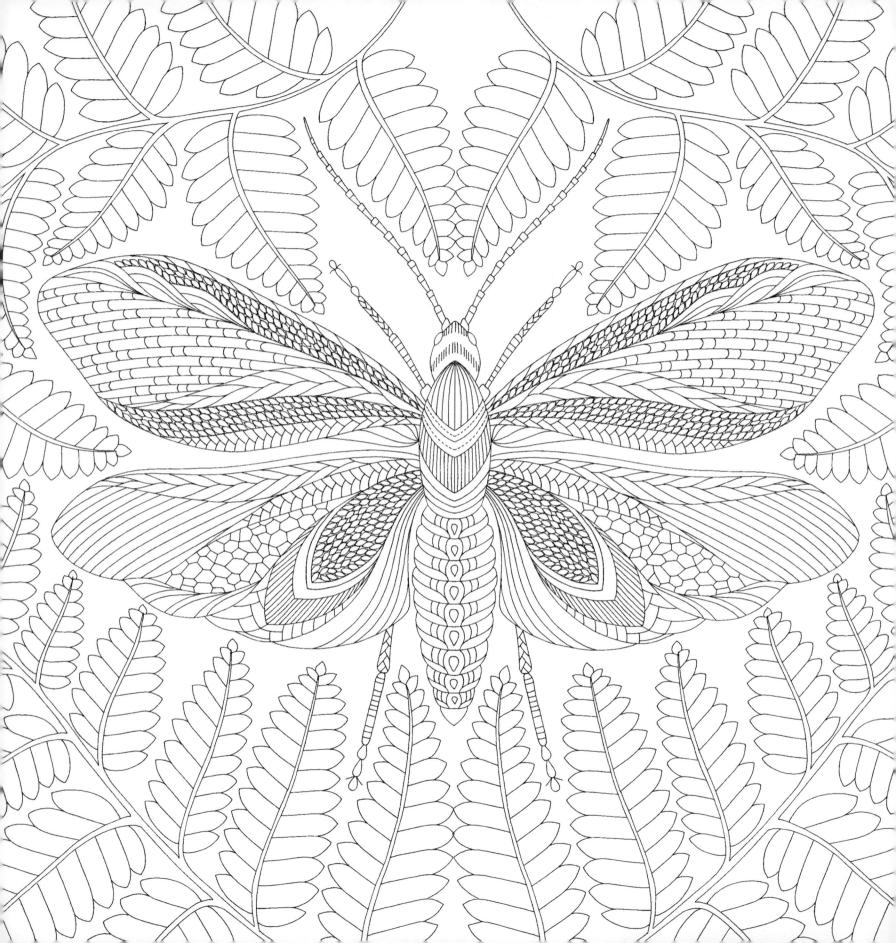

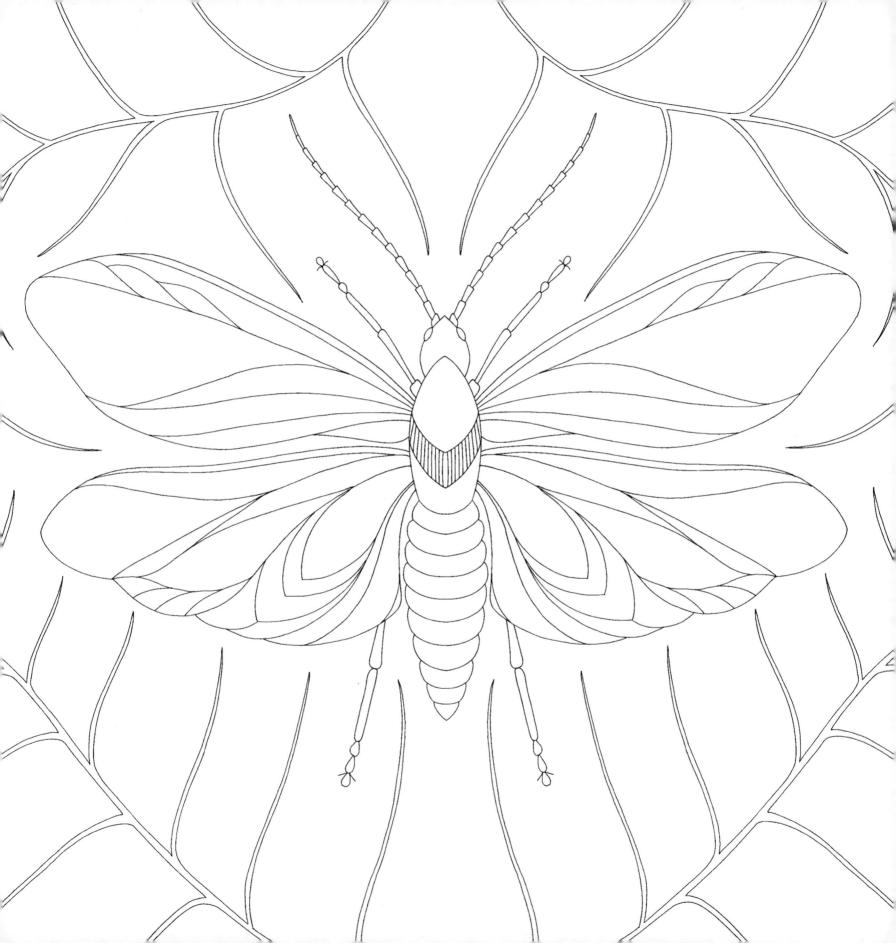

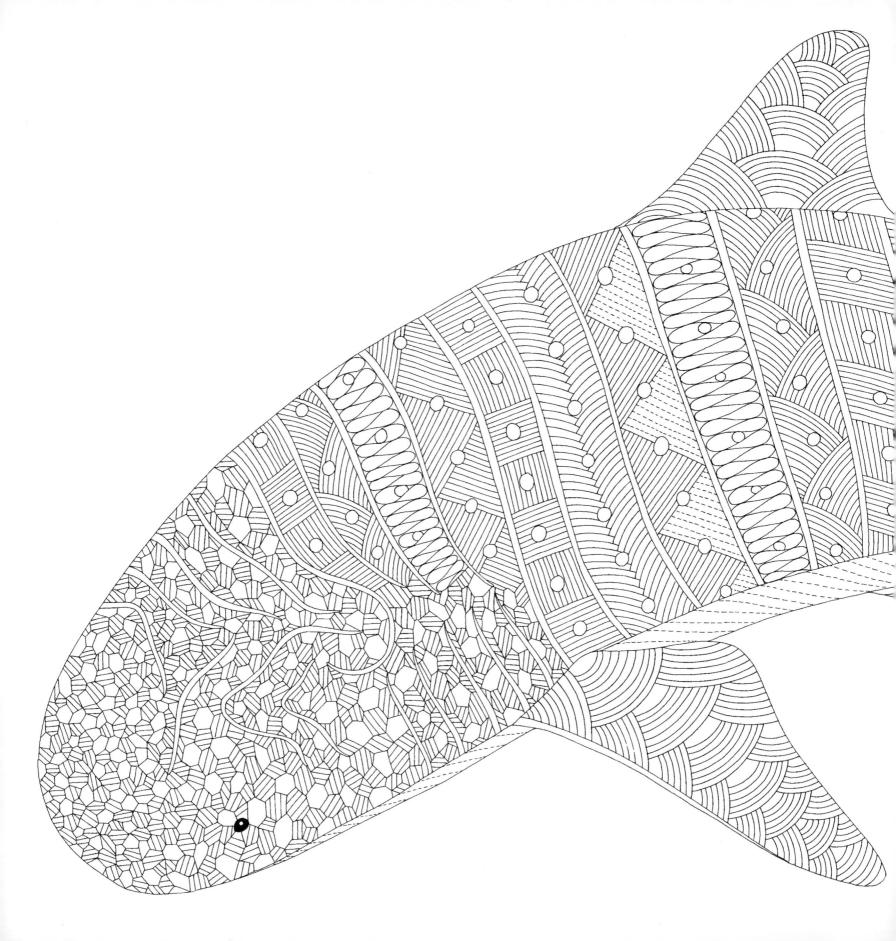

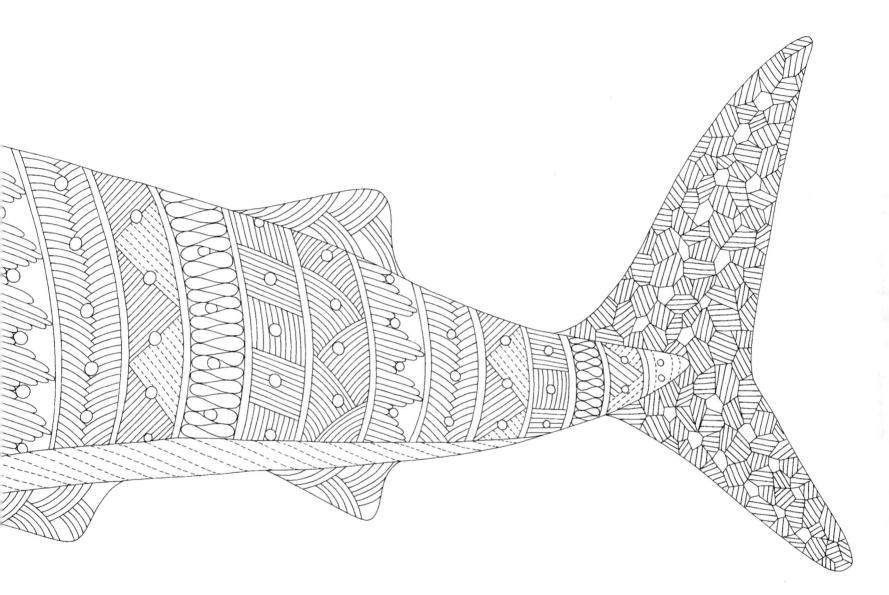

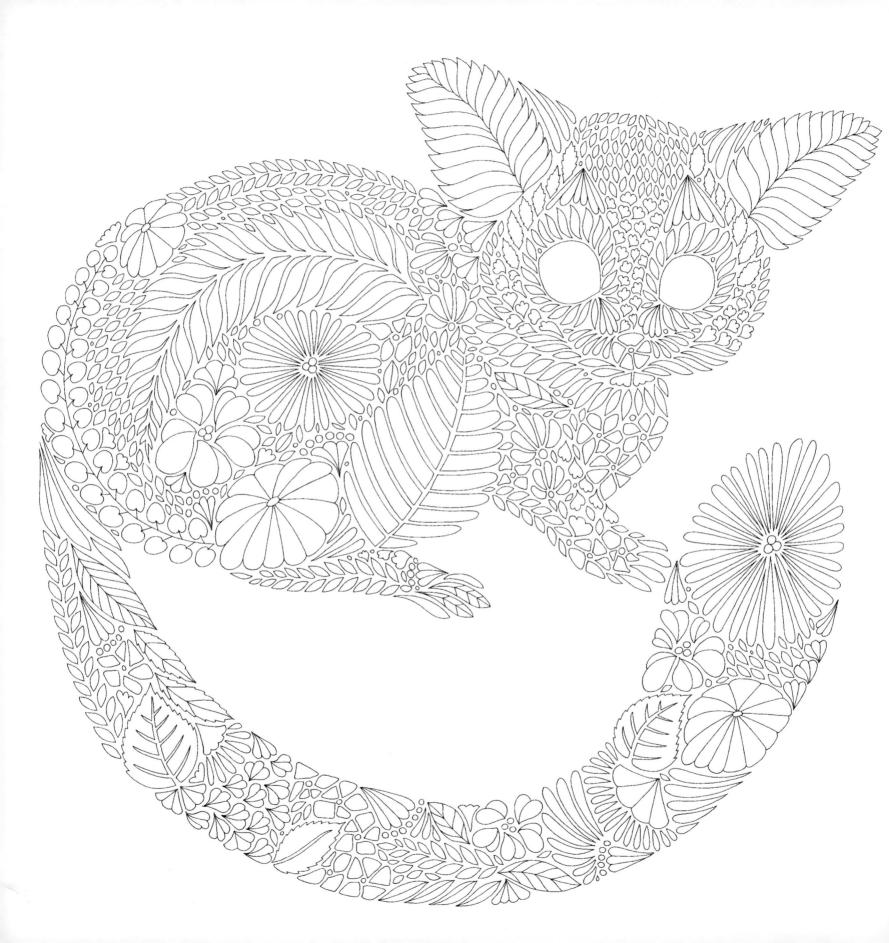

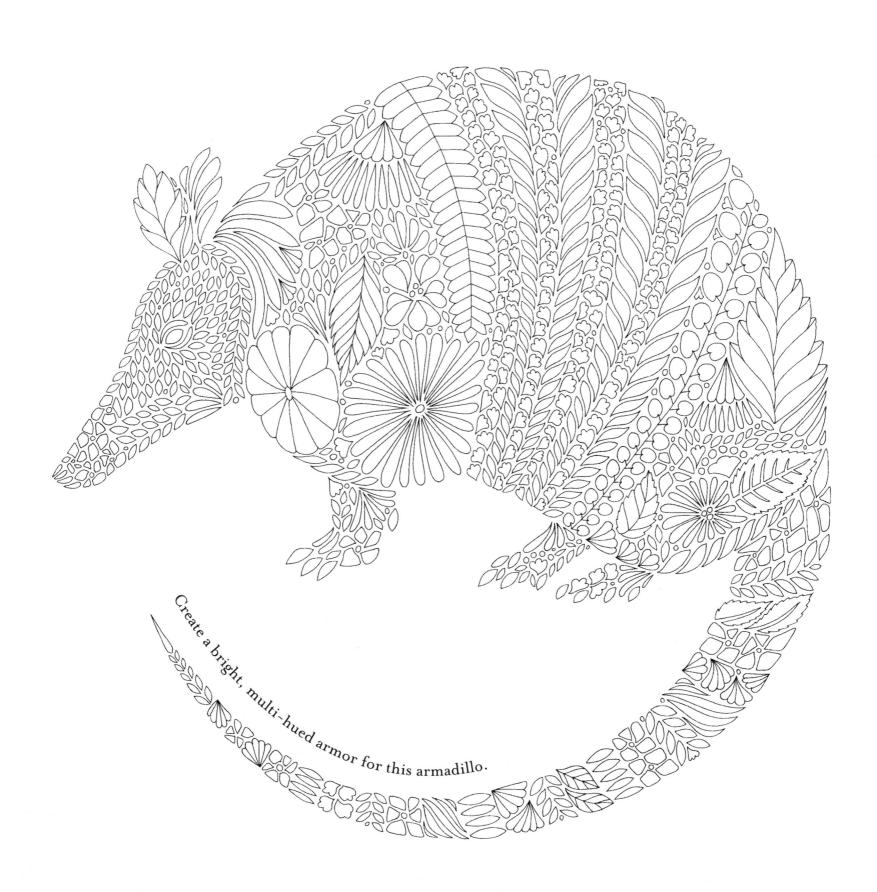

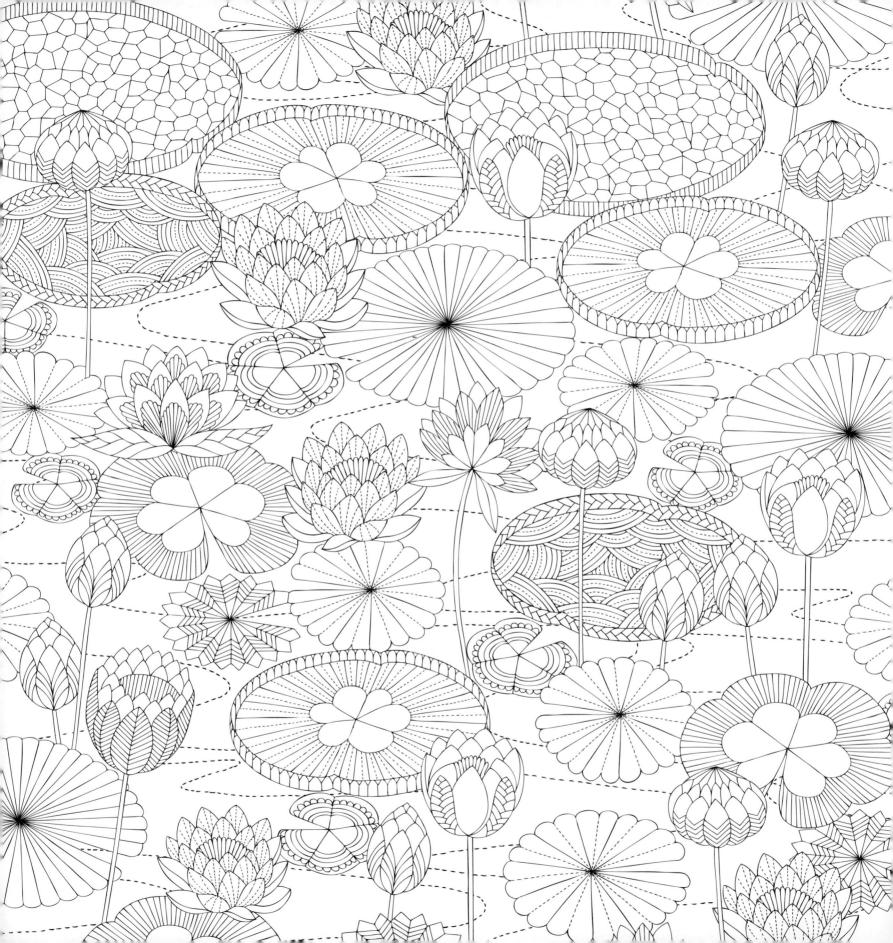

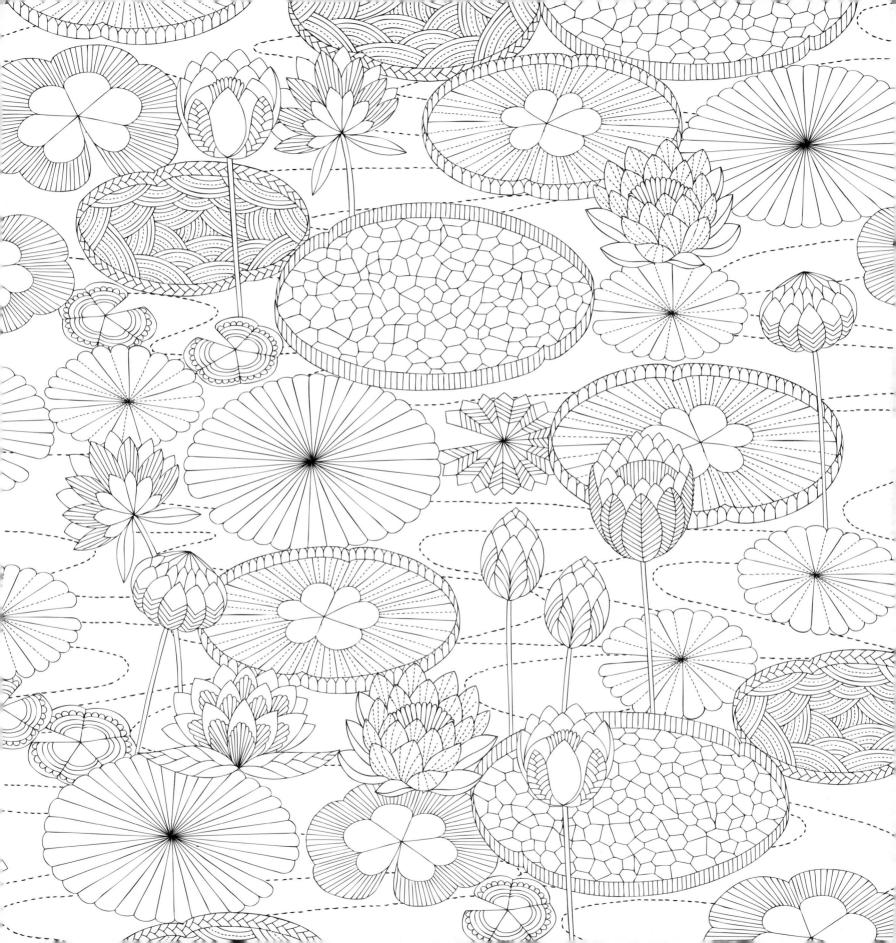

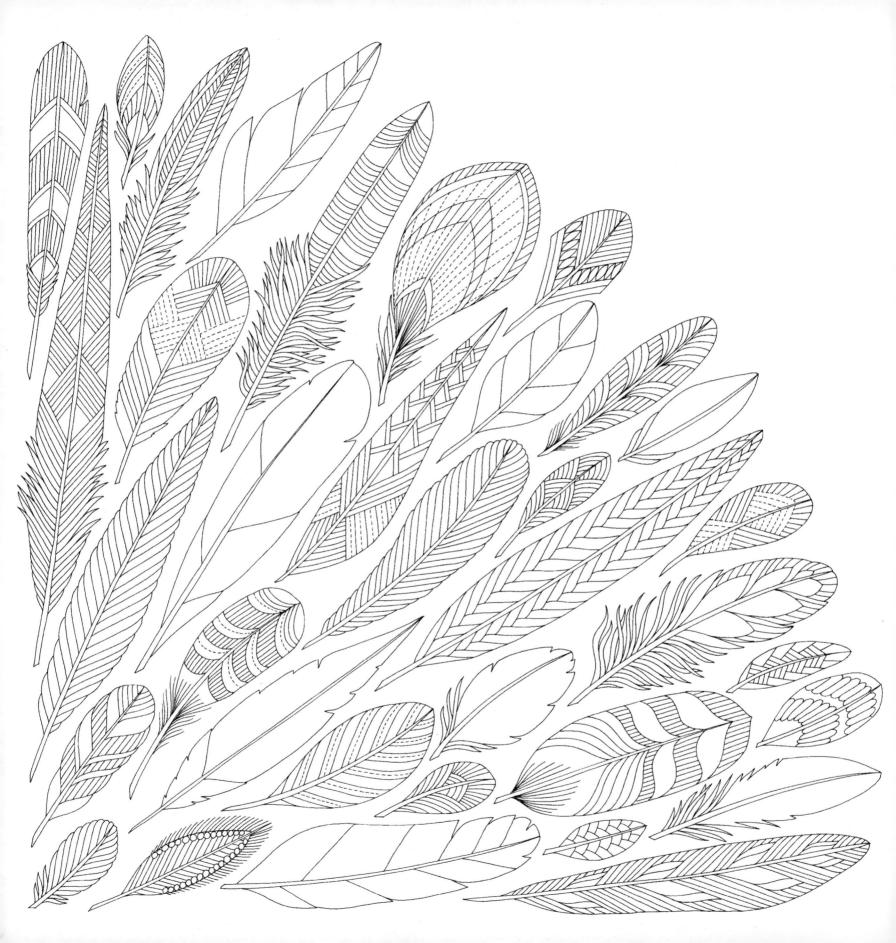

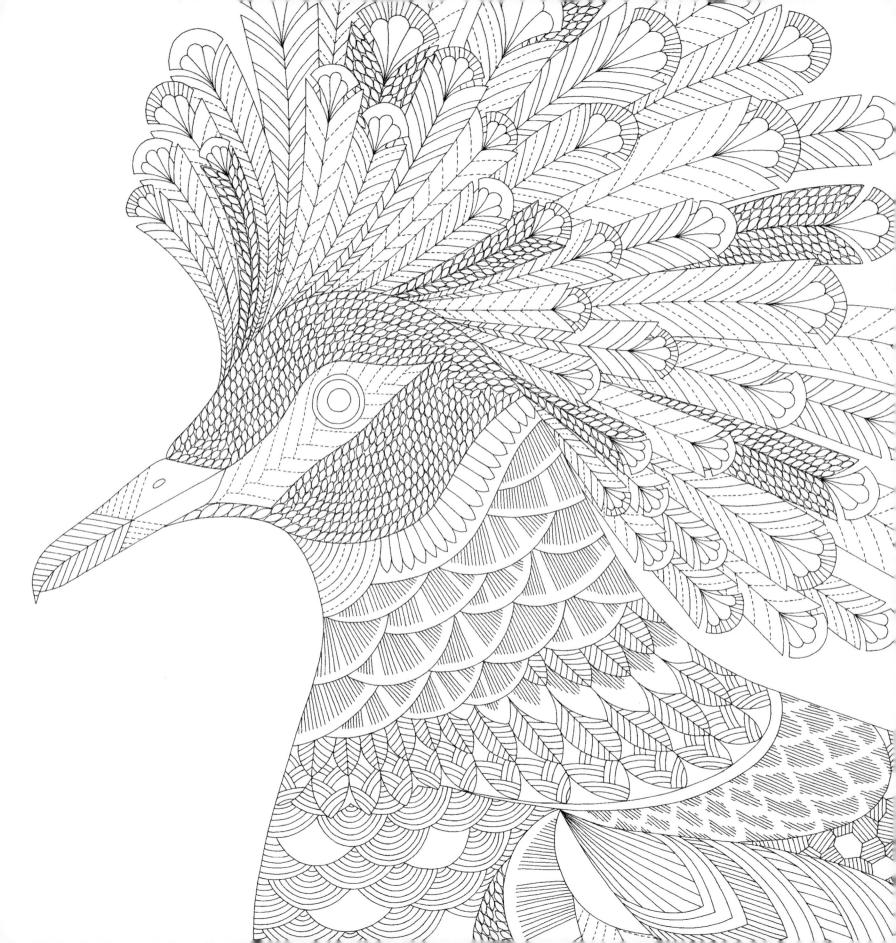

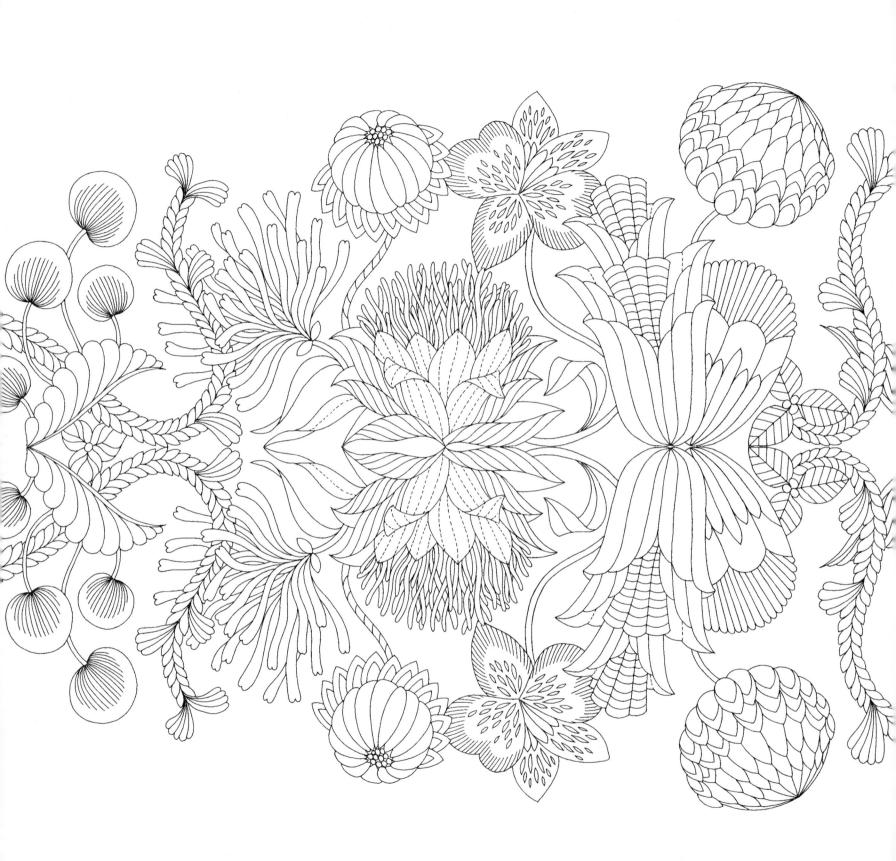

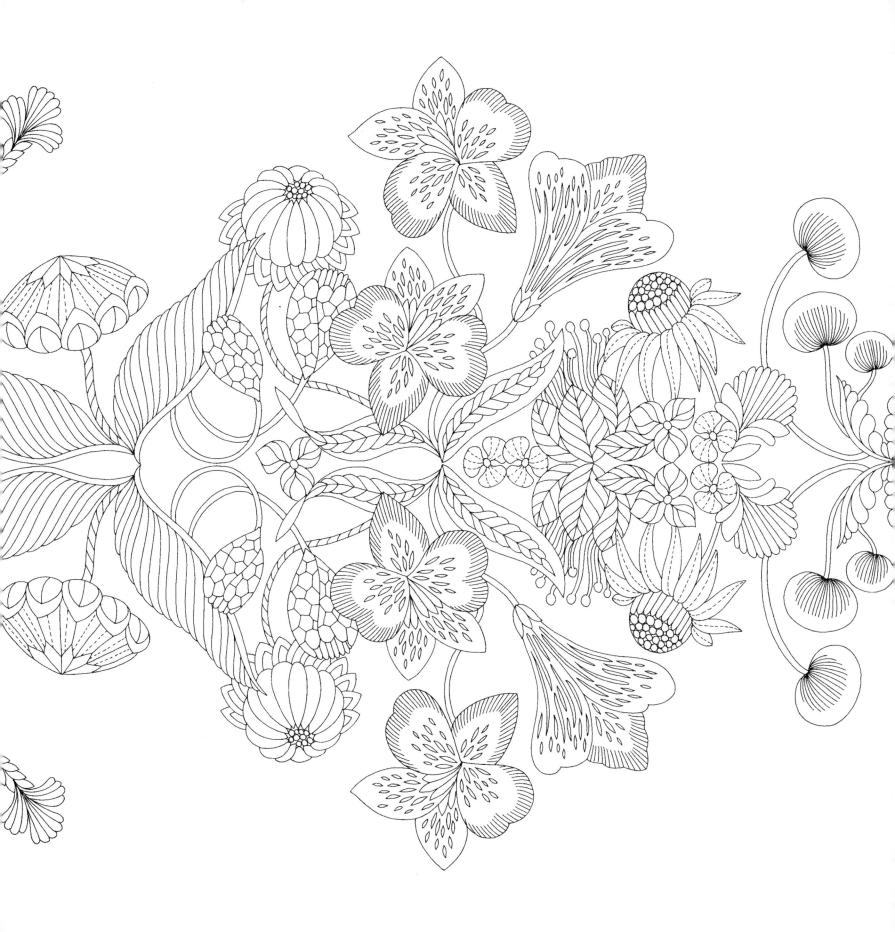

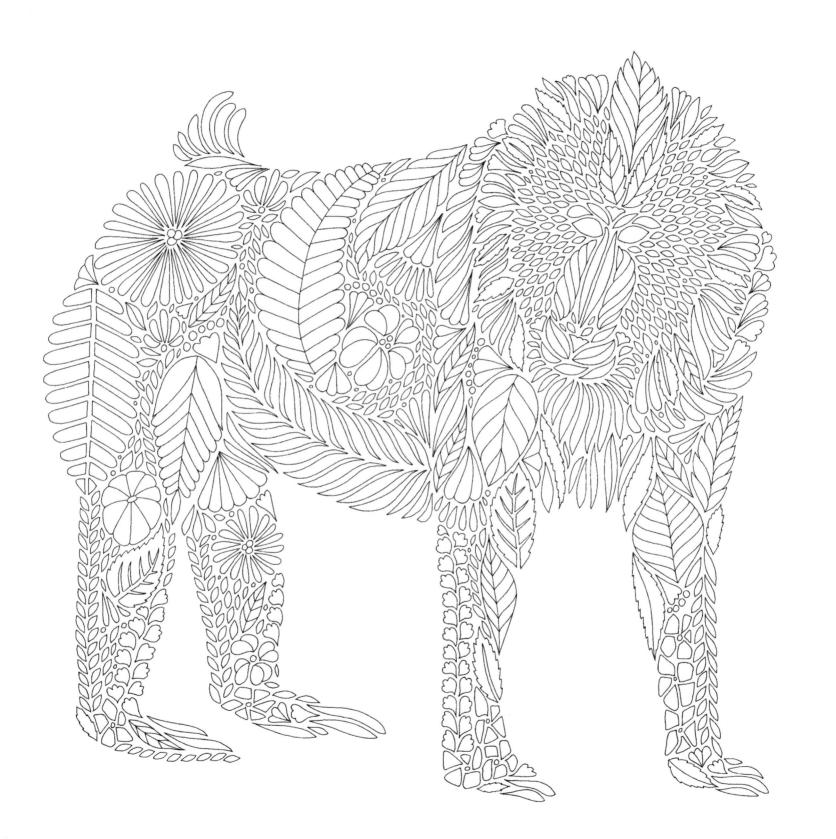

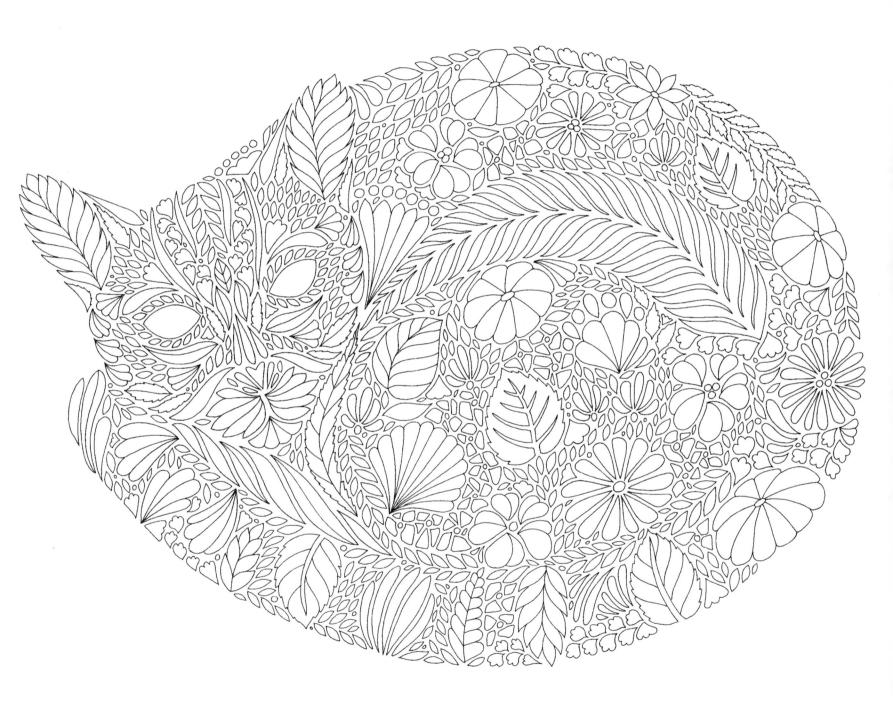

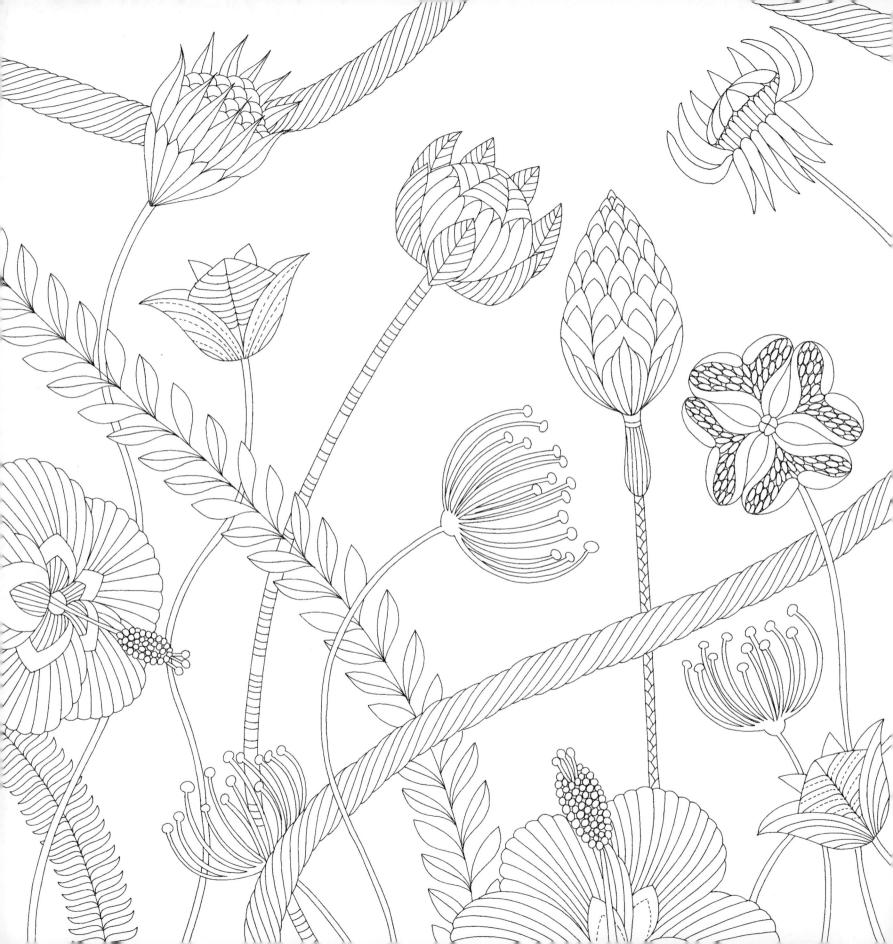

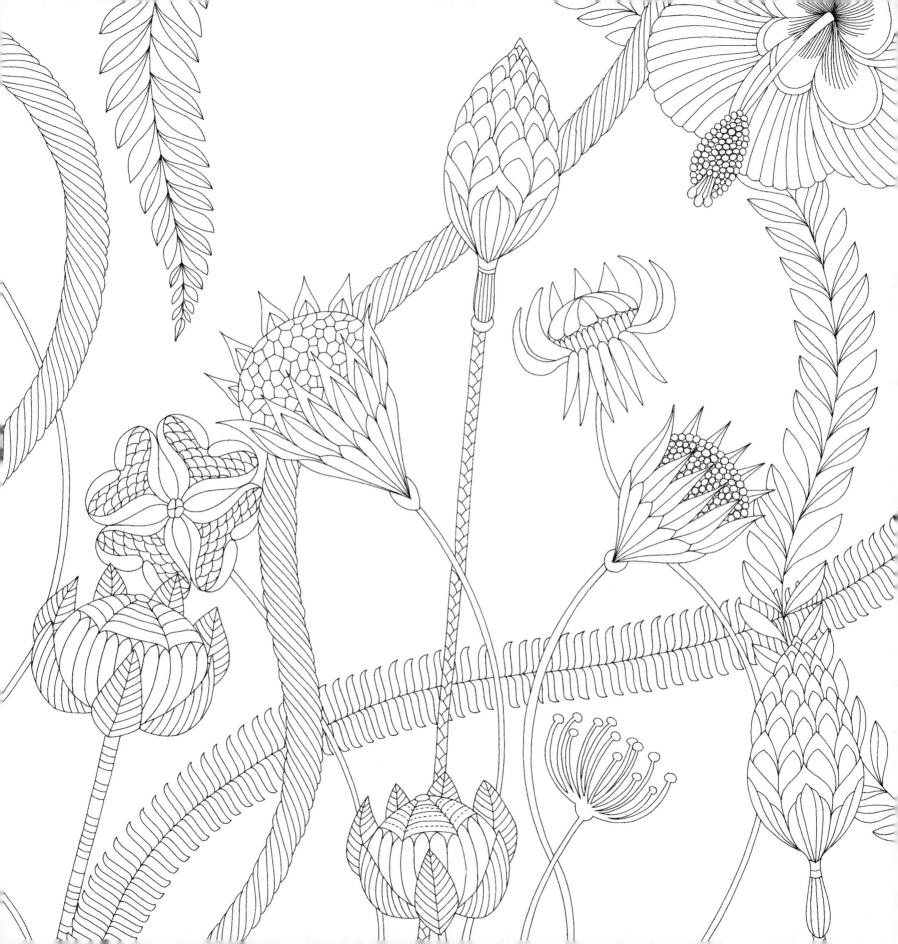

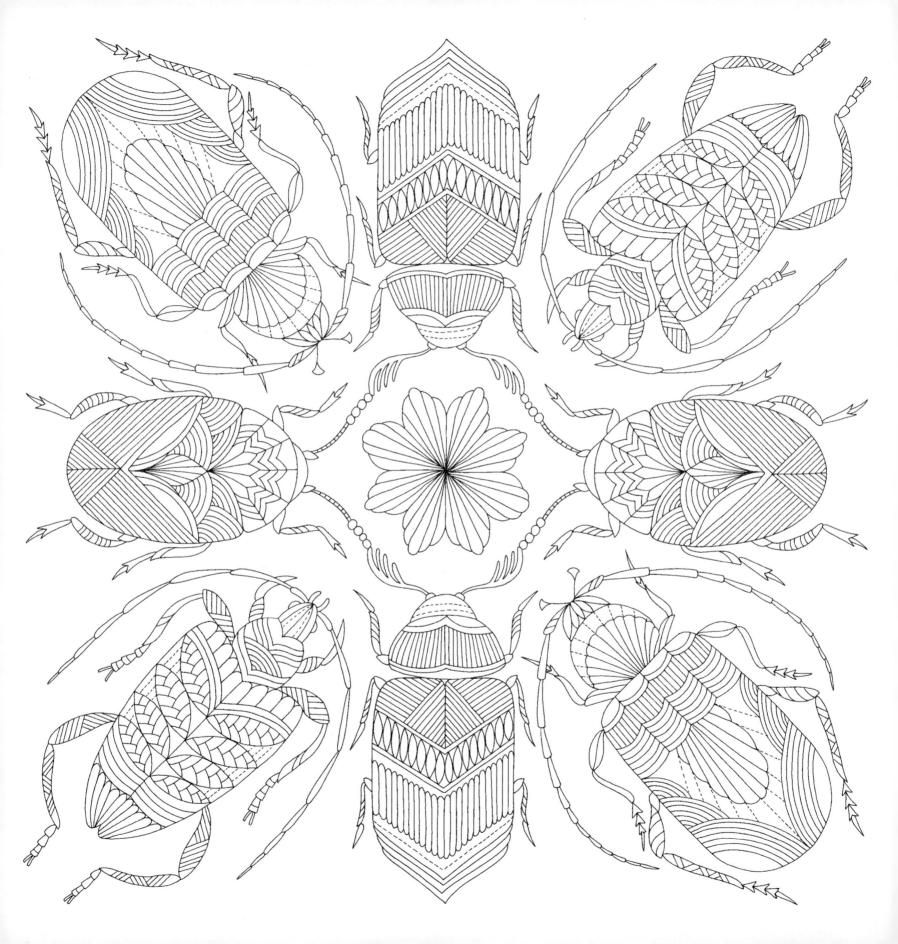

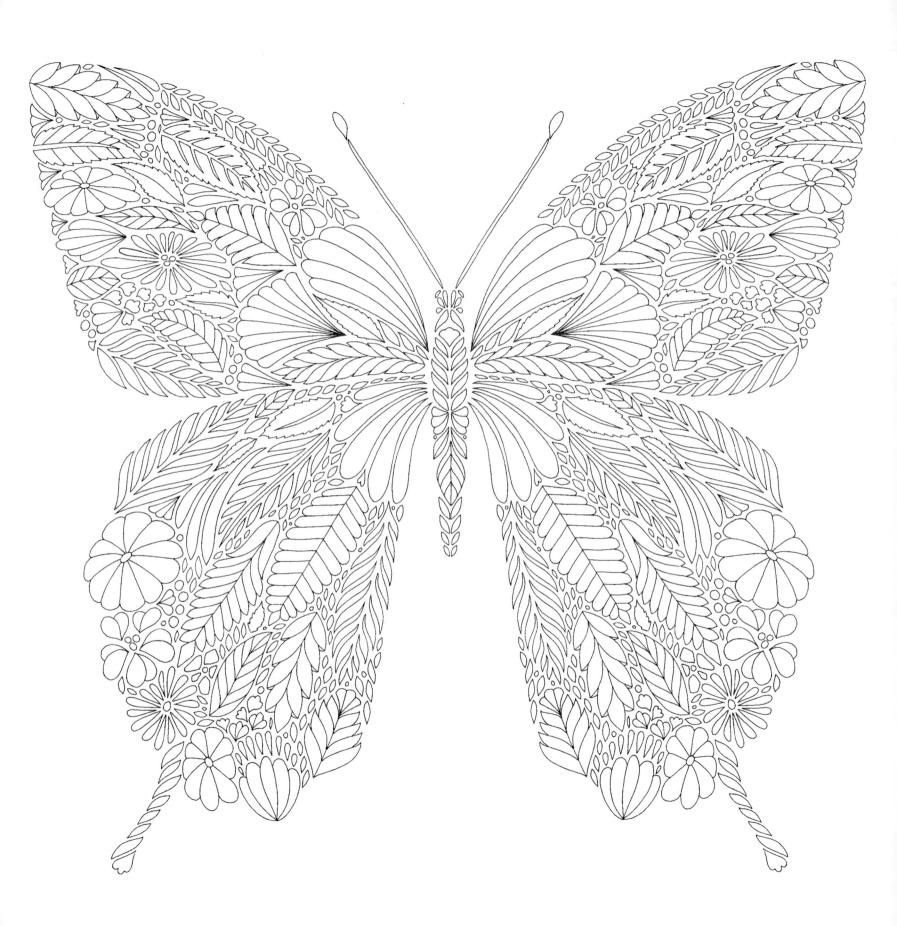

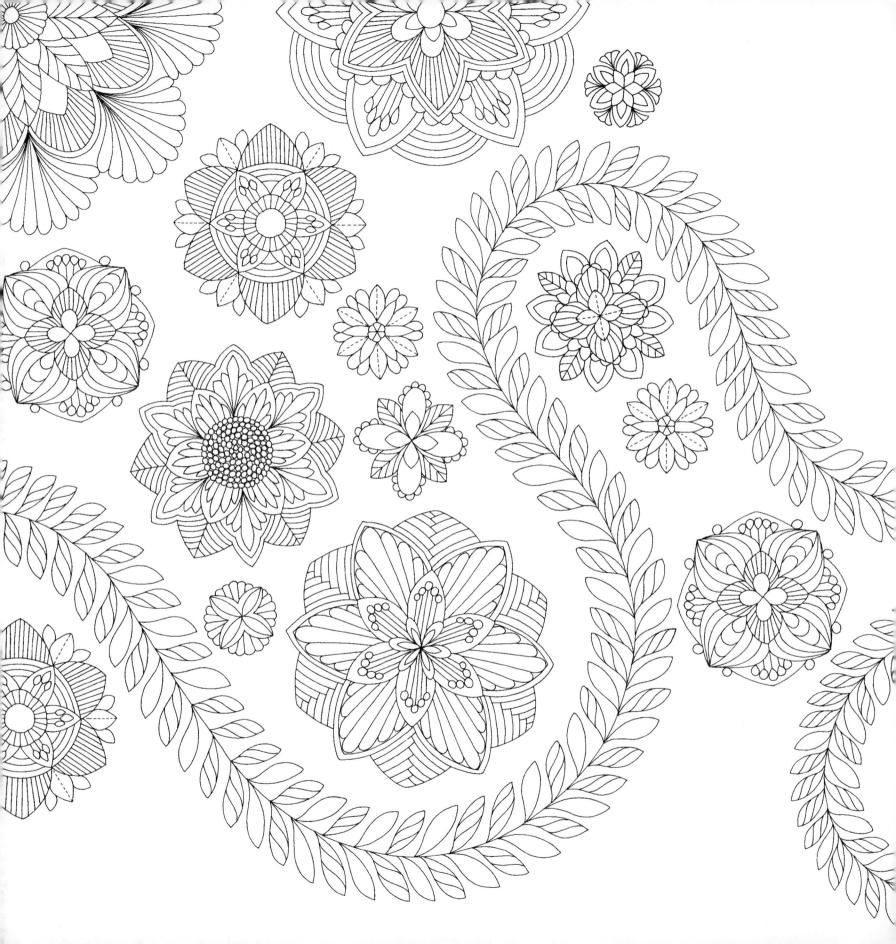

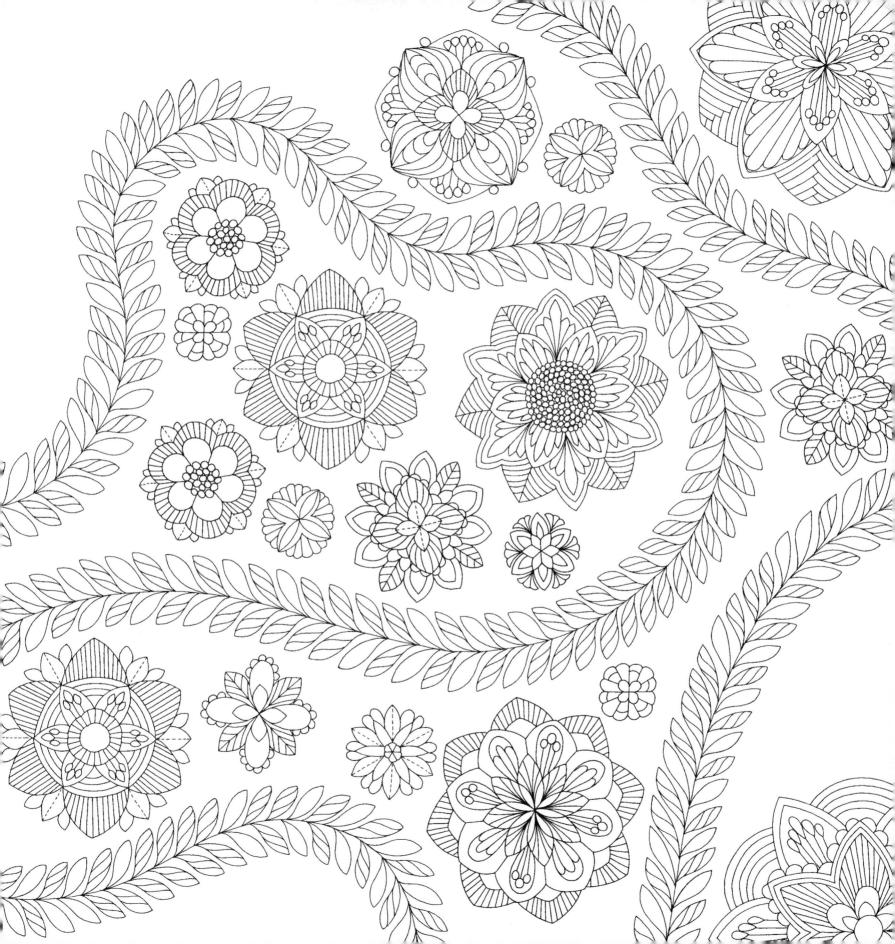

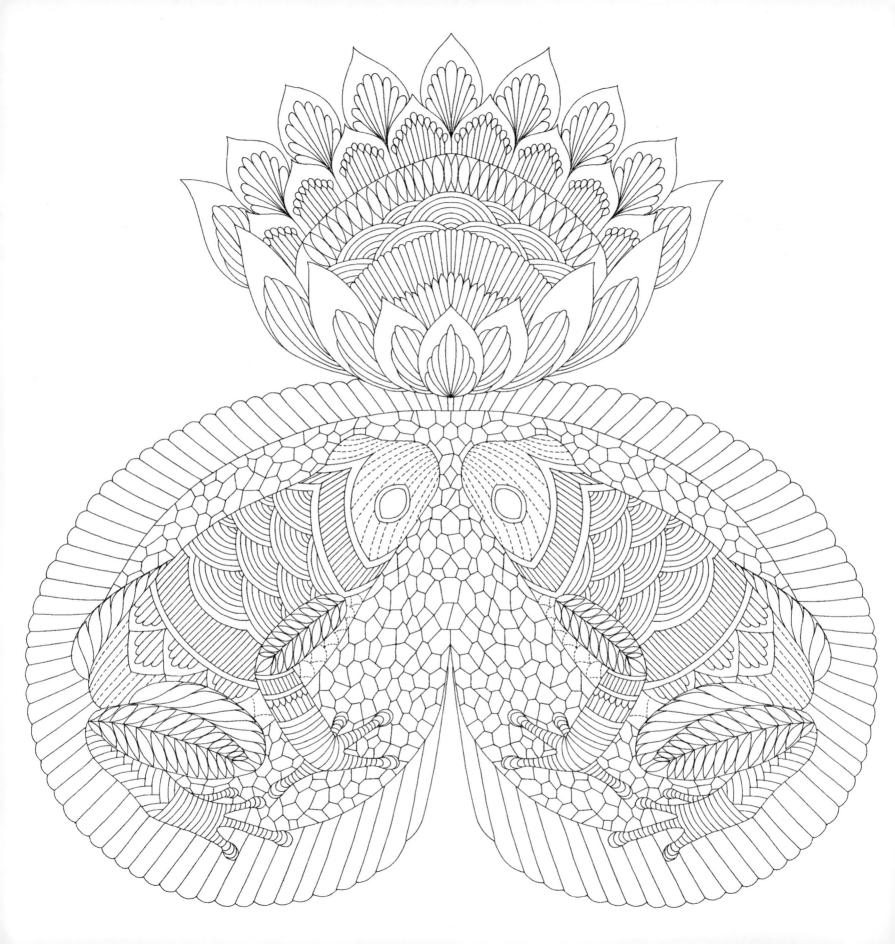

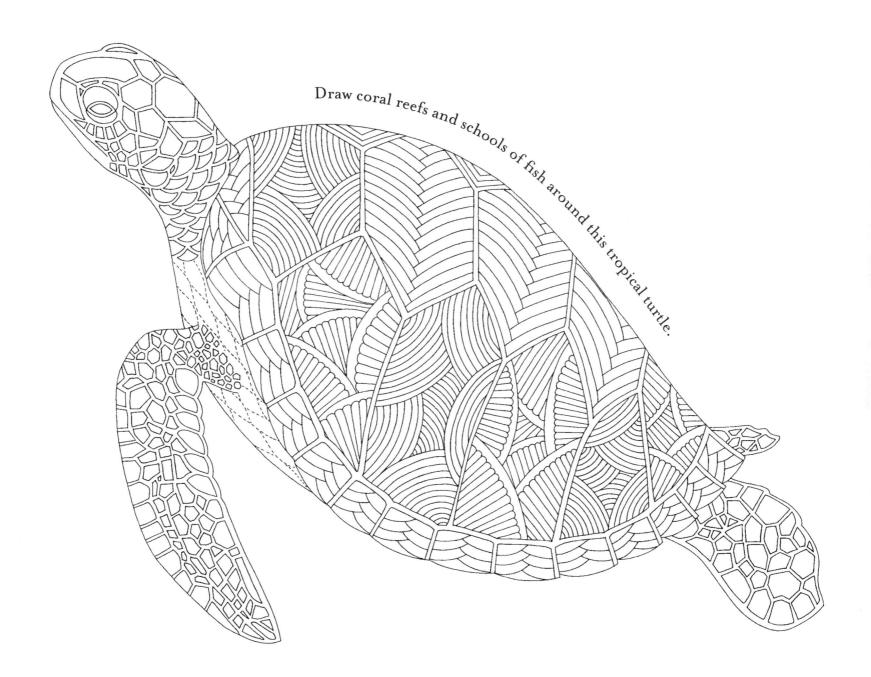

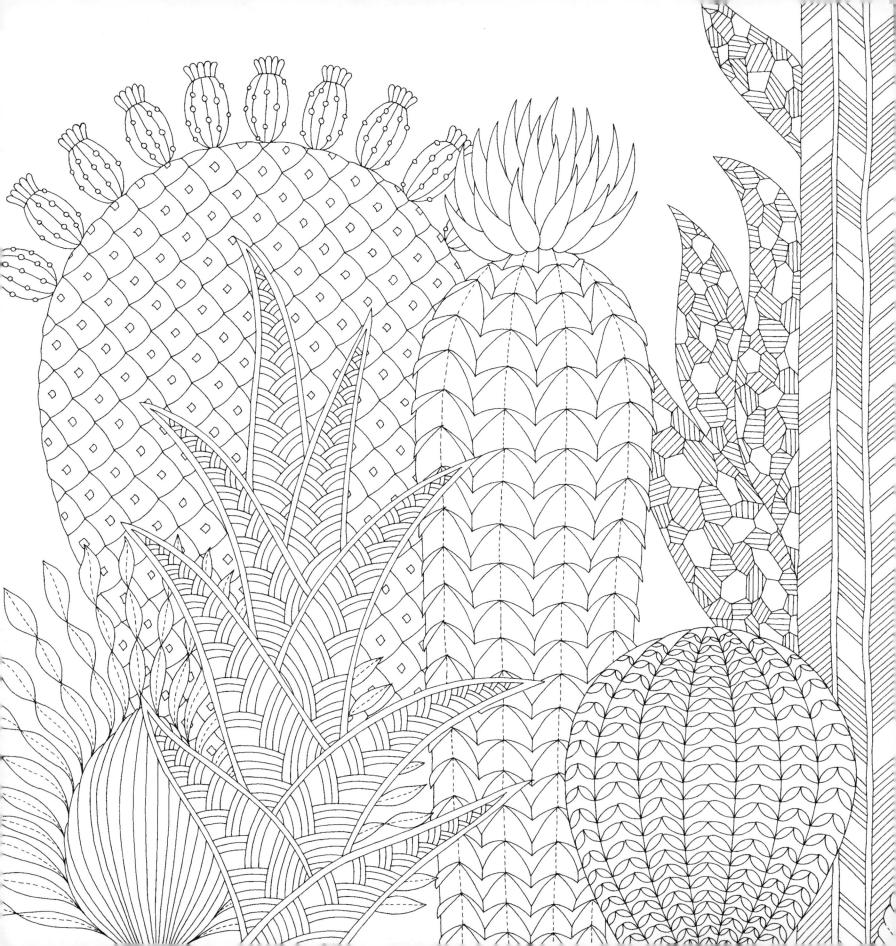

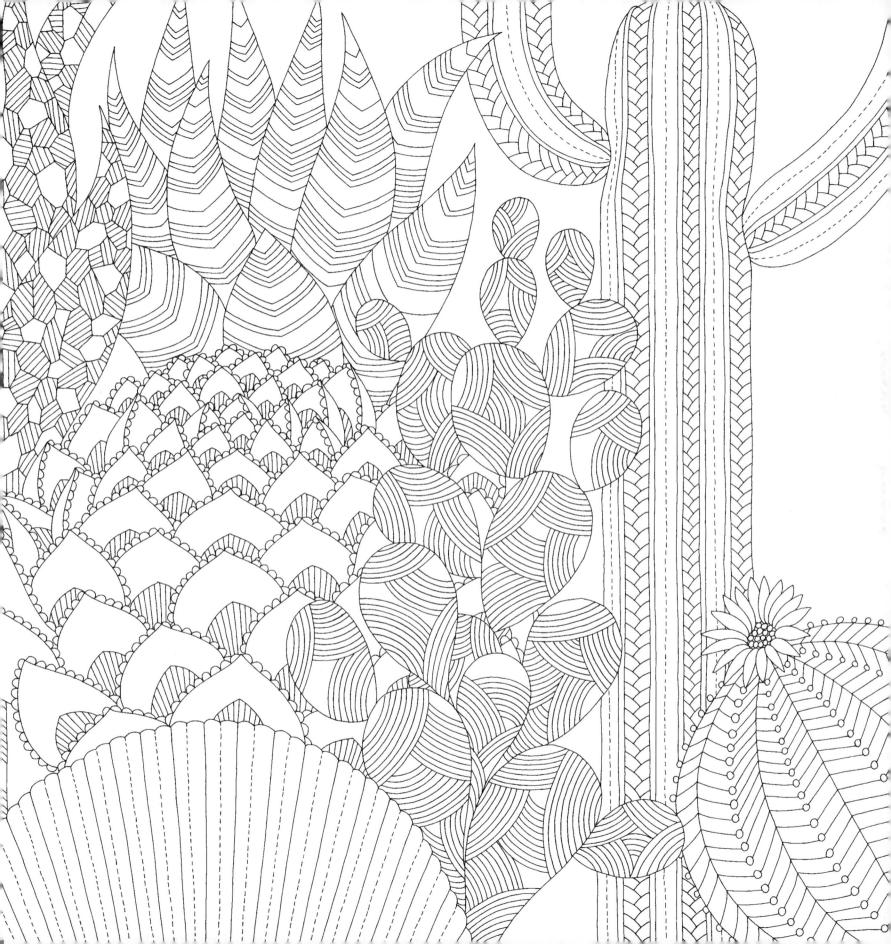

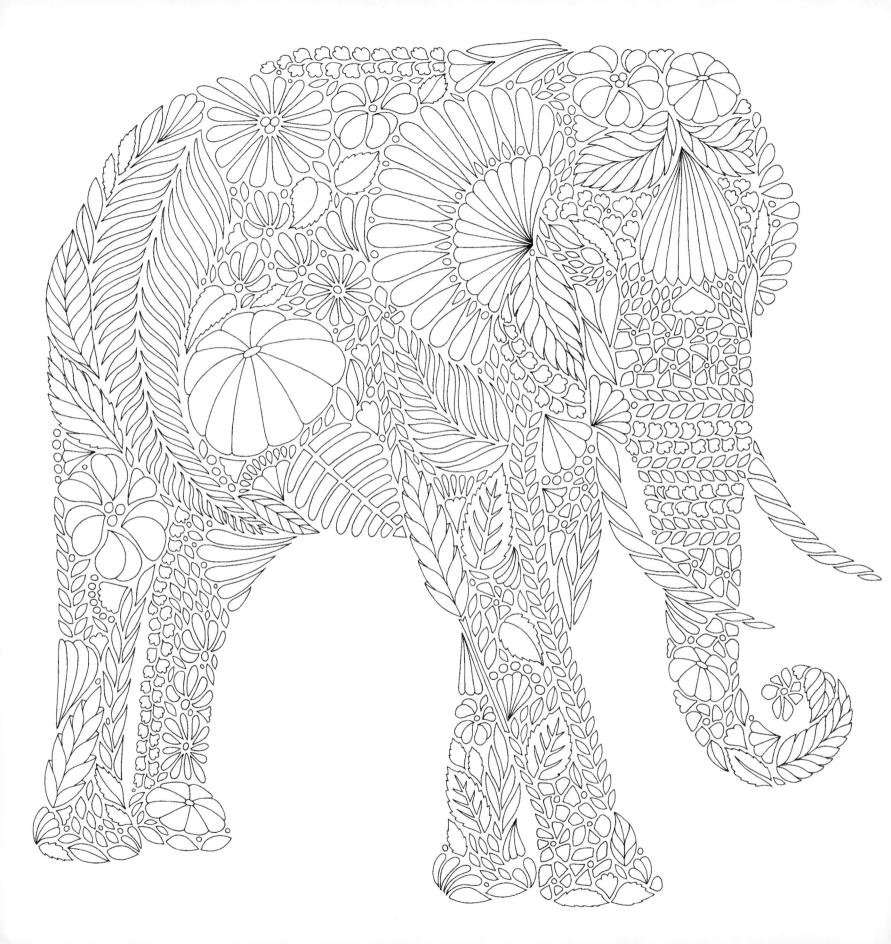

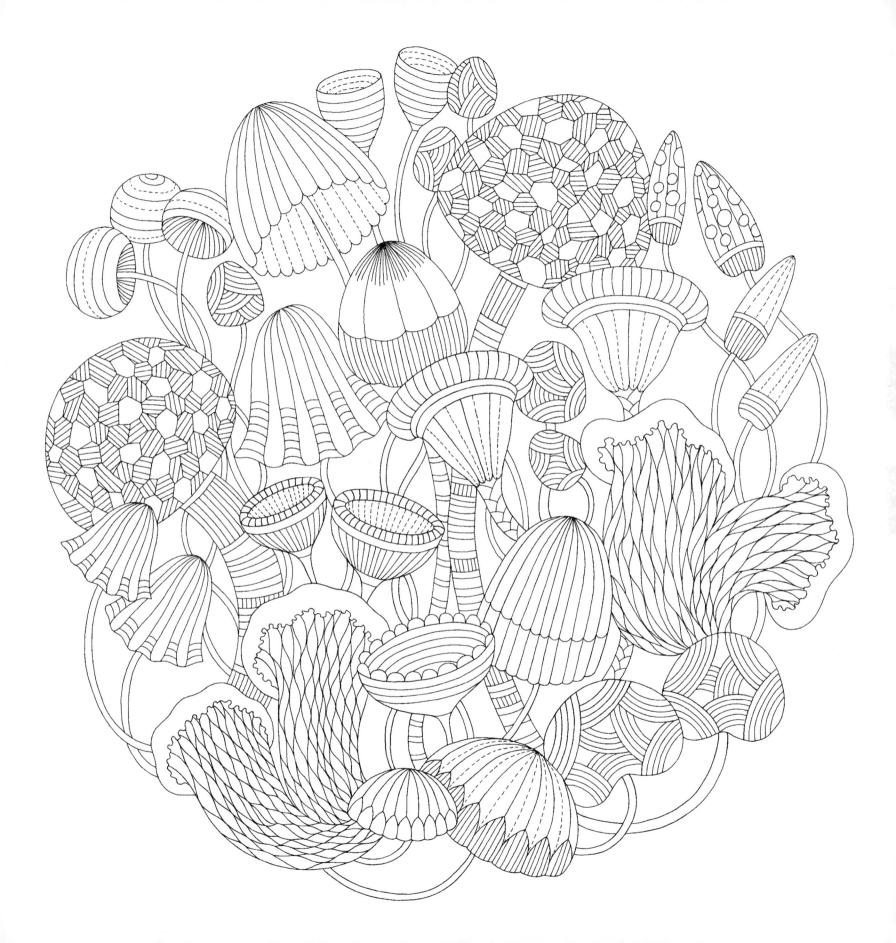

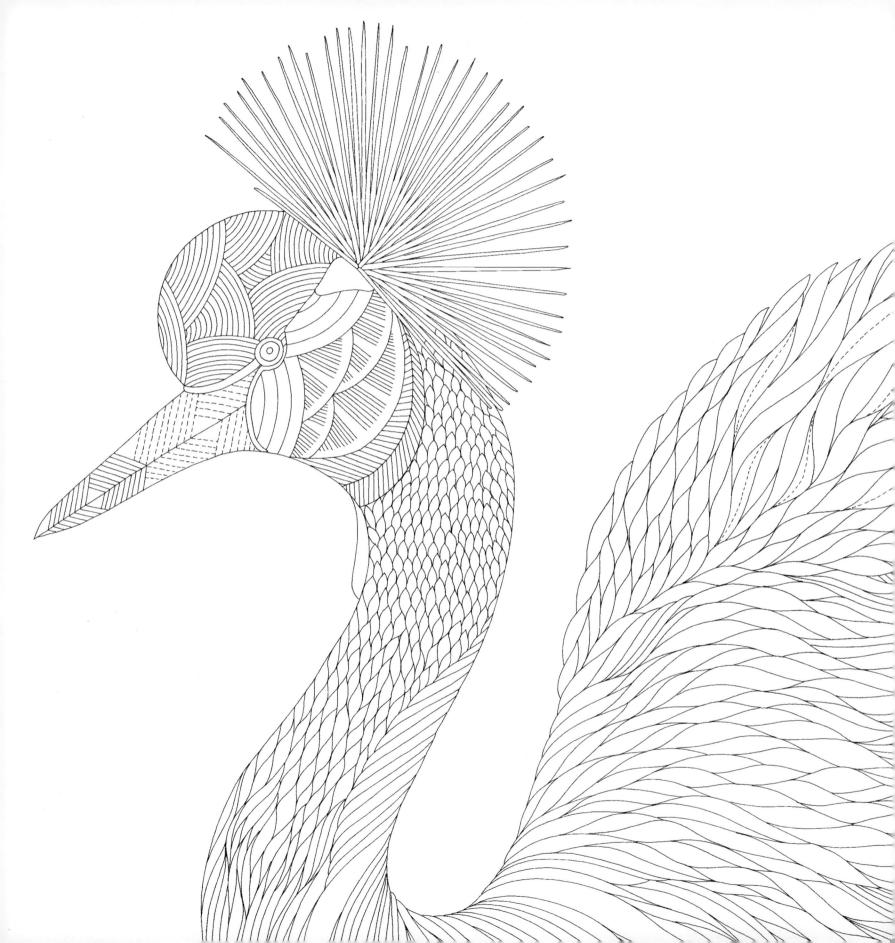

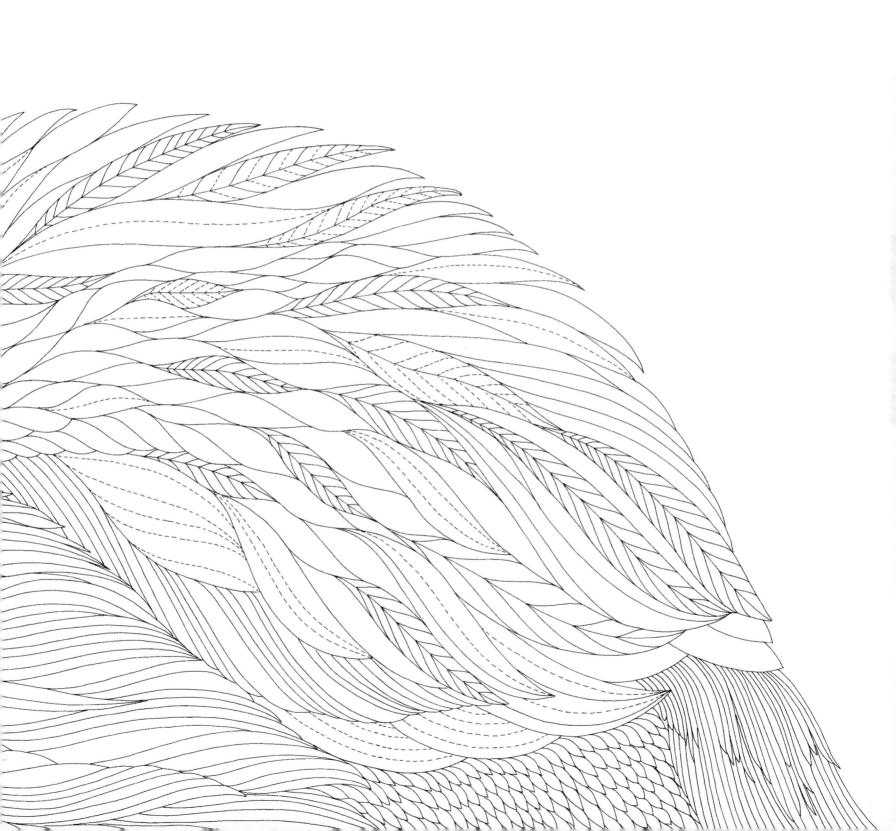

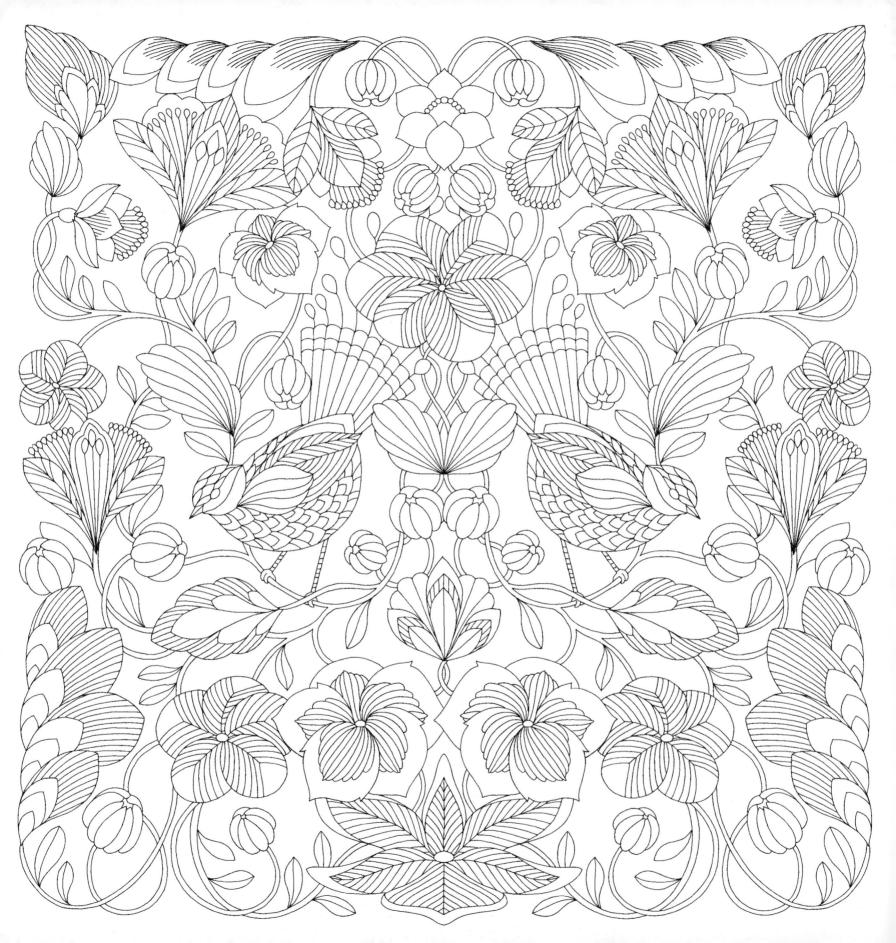

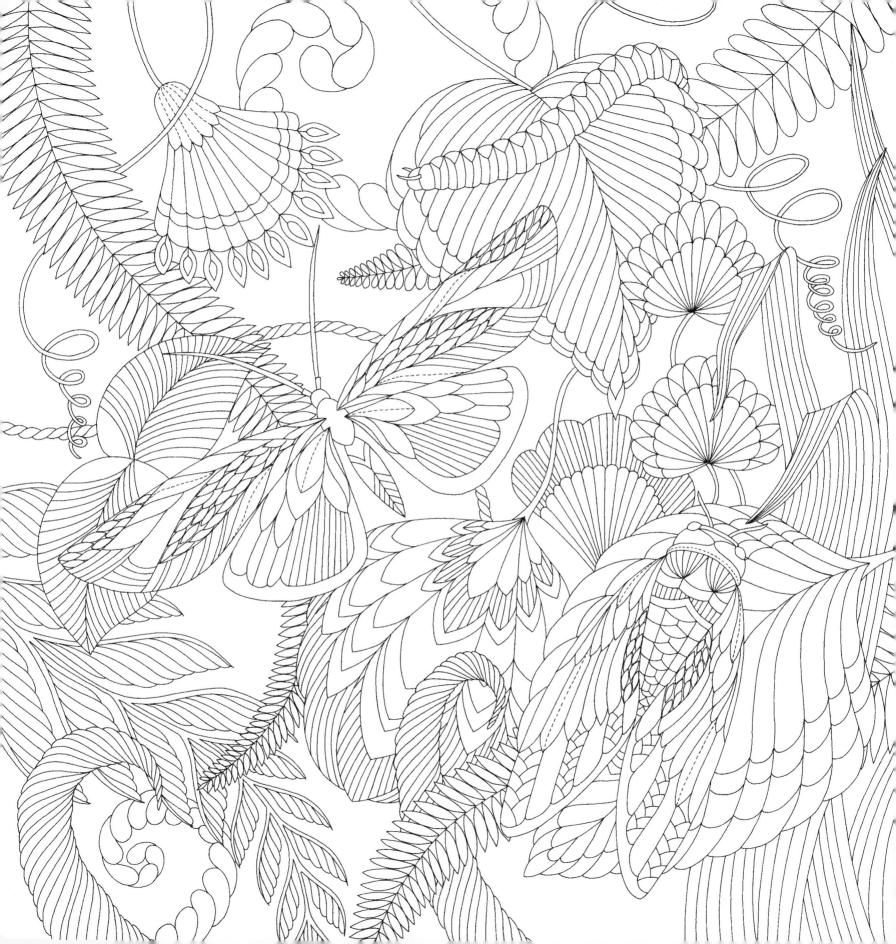

Create your own tropical paradise here...